IMAGES
of America

CHICAGO'S
MONUMENTS, MARKERS,
AND MEMORIALS

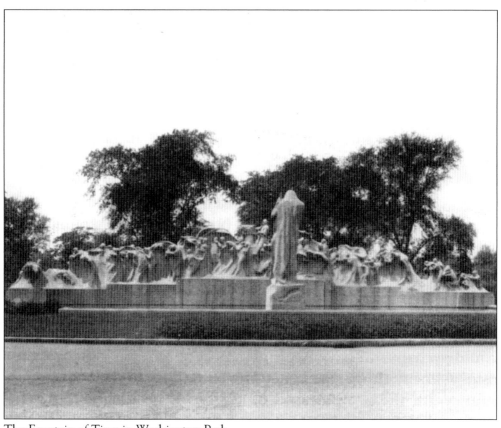

The Fountain of Time in Washington Park.

John Graf's *Monuments, Markers, and Memorials* takes readers through Chicago's parks, public plazas, cemeteries, and public buildings to recall Chicago's notable events and historic figures. From the well-known Lincoln monuments in Grant and Lincoln Parks, to the Pillar of Fire, erected at the Chicago Fire Academy to commemorate the Great Chicago Fire, to the site of the Kinzie Street Bridge where the "Great Chicago Flood" began, *Chicago's Monuments, Markers, and Memorials* provides well-known facts and lesser known details of the city's colorful history.

Monuments, Markers, and Memorials features images of 232 works of art and historical markers that range from the sublime Fountain of Time by Lorado Taft in Washington Park to a simple marker that identifies the place where Father Pere Jacques Marquette constructed a shelter on the Chicago River. As an armchair explorer, you will learn long-forgotten stories of brave and pioneering individuals in this jewel of a book.

Erma Tranter
President
Friends of the Parks

IMAGES
of America

CHICAGO'S

MONUMENTS, MARKERS, AND MEMORIALS

John Graf and Steve Skorpad

ARCADIA

First Printed 2002
Reprinted 2004

Published by Arcadia Publishing,
Charleston SC, Chicago IL, Portsmouth NH, San Francisco CA

Printed in Great Britain.

Library of Congress Catalog Card Number: 2002106599

For all general information contact Arcadia Publishing at:
Telephone 843-853-2070
Fax 843-853-0044
E-Mail sales@arcadiapublishing.com

For customer service and orders:
Toll-Free 1-888-313-2665

Visit us on the internet at http://www.arcadiapublishing.com

CONTENTS

ACKNOWLEDGMENTS

The publication of this book would not have been possible without the assistance and support of various institutions and numerous individuals and friends. I would like to thank the following people, in no particular order: Lyle Benedict at the Harold Washington Library, who seemingly knows where to find just about anything relating to Chicago; Erma Tranter and Kristine Scott for their tremendous work at Friends of the Parks, and for their continuous support of my projects; and the Chicago Fire Department, whose brave men and women are not only keeping the city safe but still manage to be gracious in their support of my book. In particular I would like to thank Fire Commissioner James T. Joyce, his secretary Marge Callahan, his brother Fireman Patrick Joyce, and the Chief of Fire Academy Operations, Steve Chikerotis.

My thanks also to Ned Broderick, President of the National Vietnam Veterans Art Museum, for allowing me unlimited access to his incredible collection; Margaret Schlesinger, Chicago Public Art Program Collections Manager; the Office of Mayor Richard M. Daley; the library staff at the Chicago Historical Society; and Robert Remer, of the Edgewater Historical Society, who was able to track down information that no one else could find. I am appreciative of the efforts of Virginia Schillo Hill and her staff at Montrose Cemetery; the staffs at Graceland, Oakwoods, Rosehill, St. Mary's, Bohemian National, Mt. Carmel, Mt. Olivet, Mt. Greenwood, and Holy Sepulchre Cemeteries; the staff of the Art Institute's Ryerson and Burnham Libraries; Kenan Heise at Chicago Historical Bookworks who knows a tremendous amount about Chicago and is always willing to lend support in whatever way possible; the Illinois Regional Archives Depository staff at Northeastern University; Rick Kogan at WGN Radio and the *Chicago Tribune*, a true Chicagoan who has helped me and countless other writers and artists to promote their works; sculptor Erik Blome, one of the most talented artists around and a heck of a nice guy; model Rebekah R. Webb; the staff of the Newberry Library for allowing us to photograph many of their works; Michael Scott, President of the Chicago Board of Education for his support while both at the Board of Ed and at his previous post at the Chicago Park District; sculptor and stone carver, Walter S. Arnold; Regas Chefas, owner of Gethsemane Garden Center; James Cooney at PNTN; Anne Berquist; and Lee Balterman.

I am also grateful to Lester Coyle and Janet Whitton, who truly appreciate architecture and, in addition, were an inspiration to me in my writing; Carmella Hartigan, the world's greatest Cub Fan; John and Pat Hartigan, two wonderful friends who have always supported my endeavors; Paul and Denise Ryske for their great sense of humor that always keeps me going; Donna Placio, the best physical conditioning guru around; Hans and Silvia Daehn for their kindness and support; Matt, Lori and Mary Jo Kelly for their continued friendship; Tom Regan Jr., a true gentleman and all-around nice guy; Joe Cornell at Spin-Off Advisors, a great friend for over thirty years; and Don Watkins, another longtime friend.

Finally, I acknowledge the help of John Pearson and the staff at Arcadia Publishing for making this book happen; Steve Skorpad for his wonderful photography that fills many of the pages of this book, as well as his wife, Judy, and their son, Stevie Skorpad Jr., for their patience and understanding while we worked on this book for months on end; Jim and Rosie Blaszczyk for their unwavering support; my late father, Werner, who sparked my interest in Chicago at a very early age, and my mother, Mercedes, who has encouraged me in my quest to be a Chicago historian; and last, but not least, my wonderful wife Marina for always believing in me.

FOREWORD

Chicago is famous for its architecture. Yet alongside this architecture, and often within it and upon it, are monuments, markers, and memorials that are among the finest examples to be found anywhere. John Graf's excellent book shines a much needed light on these historical artistic objects.

Using all of the historical resources at his disposal, John Graf has created a book that can serve as a guide for Chicagoans to educate or re-acquaint themselves with the existing monuments, markers, and memorials that define the City of Chicago and give it a human face. Illustrated with pictures and descriptions that will entice many readers to visit these places in person, the book catalogs and brings to a fore hundreds of sites and creations that might otherwise remain ignored as background filler in many of our fast-paced lives.

The book gives us the context and meaning of the pieces, which opens up a world of historical imagination to the viewer. This appreciation, accompanied by an appreciation and understanding of the months, years, and sometimes decades of dedication and toil that artists and craftsmen devote to single memorials, can leave one awestruck. Pictured in this book are works by some of the greatest artists and craftsmen anywhere. Among them are world-famous sculptors like Augustus Saint-Gaudens and Chicago's own Lorado Taft.

Ignored does not mean forgotten, and forgotten does not mean gone forever. While some things go in and out of style, important commemorations take on a permanent symbolic significance, socially and historically. In the second half of the 20th century, there was a decline in the appreciation of commemorations such as those that appear in this book. Like a loud drunk at a party, and with much fanfare, spectacular forms of contemporary art took center stage and drowned out the quieter forms of expression that had lasted for centuries, leaving them to be ignored at the other end of the room. Consequently, it was positively not avante garde to like things from the past, and these traditional memorials became unpopular.

One can't help but notice how attracted we are to what is the visually loud in American culture. Eye-catching images are what we seem to appreciate most. Yet, look at the objects and commemorations in this book carefully, and I think one can't help but notice the value that was once attributed to the subtle pose and the quiet powerful image.

The end of the 20th century undoubtedly began to see the revival of the traditional forms of art and architecture and the realist spirit in public sculpture and art. John Graf's book is timely in that many people have already renewed their interest in these things and are looking for a good book to guide them through Chicago's many wonderful and exciting monuments, markers, and memorials. Here it is.

Erik Blome
Sculptor
June 8, 2002

INTRODUCTION

Chicago is a city that is filled with history. In nearly every neighborhood, monuments, markers, and memorials have been erected to commemorate this history. It is safe to say that Chicago has one of the richest collections of such commemorations to be found anywhere in the world. While many of these works were completed by local or virtually unknown artists, others were created by world renowned artists, architects, and sculptors, including Pablo Picasso, Lorado Taft, Louis Sullivan, and Augustus Saint-Gaudens. Whether they commemorate events like the Haymarket Riot, captains of industry like Marshall Field, sports heroes like Michael Jordan, or famous politicians like early Chicago Mayor John Wentworth, each of Chicago's monuments, markers, and memorials has an interesting story to tell.

Since the founding of Chicago on March 4, 1837, the city has been a port of entry for nearly every ethnic and racial group imaginable. The commemorations found throughout the city are a reflection of this. The Germans look to their statues of Goethe and Schiller, while the Italians assign special significance to their monuments of Garibaldi and Columbus. The Swedish value the Linne sculpture, the Polish community point to the Kosciuszko monument, and the Norwegians regard the Leif Ericson Memorial with great pride. In addition, Mexican-Americans honor the likeness represented in the statue of Benito Juarez, the Puerto Ricans call attention to the statue of Pedro Albizu-Campos, and native Americans are honored with statues in Lincoln Park. Finally, African-Americans pay respect to great men with their memorials to Harold Washington and Thurgood Marshall, while other ethnic groups not mentioned here honor their heritage with designated memorials placed throughout the city.

Chicagoans have a keen appreciation of their history and they tend to immortalize well-known figures who are associated with it. This is reflected in the number and types of statues built to honor early heroes in the city's history, heroes like General Philip Henry Sheridan and Mayor Carter Harrison. Other markers and memorials testify to the efforts of Chicago industrialists such as George Pullman and Aaron Montgomery Ward. More recent works pay tribute to Chicago legends like Harry Caray and Jack Brickhouse.

Chicago is also a city of contrast, and its artwork reflects this. While the Douglas Monument stands nearly 100 feet tall, the bronze sculpture of *Jacob and the Angel II* is less than two feet in scale. The Jacques Marquette Monument and the Fort Dearborn historical marker were created to record events that played major roles in the development of Chicago, but the Eastland Disaster Marker and the Iroquois Fire Memorial are reminders of tragic events that took place in the city. Finally, the violent nature of Rohl-Smith's Massacre Monument stands in stark contrast to the peaceful nature of Taft's sculptures that sit in the serene setting of the Garfield Park Conservatory.

With the terrorist attacks on the World Trade Center on that fateful day, September 11, 2001, there has been a pronounced emphasis on recognizing heroes around the country. Yet the people of Chicago have always valued their heroes, which is evidenced by the fact that there are monuments throughout the city dedicated to the courageous firefighters and policemen who have been killed in the line of duty. Two of the most sacred monuments that preserve their memories, for example, are the Honored Star Cases of the Chicago Fire Department and the Chicago Police Department. Located in the lobby of the Chicago Fire Department Training Academy, the firemen's honored star case contains the badges of nearly 600 firefighters who

were killed while battling blazes in the city. The policemen's Honored Star Case (found in the lobby of Chicago Police Headquarters) displays the badges of the nearly 500 officers who lost their lives in the line of duty since 1854.

There are a number of unusual facts about Chicago's monuments, markers, and memorials—which make for good dinner conversation. Many Chicagoans know there is a statue of Grant in Lincoln Park and a statue of Lincoln in Grant Park. But most people don't know that the Andreas Zirngibl monument stands in the middle of a scrap yard; and while Pablo Picasso never visited Chicago, his work in Daley Plaza has nonetheless become a symbol of the city. Another remarkable fact about Chicago monuments is not so much who they memorialize, but rather who they ignore. For example, there is no statue of Mayor Richard J. Daley or architect Daniel Burnham, and other than a small memorial to Jane Addams, there are almost no markers to be found honoring women.

Although many fine monuments, markers, and memorials can be found in Chicago, extreme heat in the summer months and subfreezing temperatures in the winter have taken their toll on these works over the years. Problems with vandalism and theft have caused even more damage. Recently, concerned citizens, various groups (such as Friends of the Parks), and the City of Chicago, under the leadership of Mayor Richard M. Daley, have gone to great lengths to protect these art forms. Today there is better security and many works are being covered from the elements while others are being cleaned and refurbished. Despite some damaging weather conditions, Chicago is protecting and preserving these works like never before.

Finally, there is only so much that can be said about a particular photograph when captions are restricted to a few sentences. It is my hope that this book will stimulate and encourage a wide range of readers, from the neophyte to the serious historian, to visit the various monuments, markers, and memorials in Chicago that are discussed here. The less athletically-inclined may decide to remain at the coffee table and enjoy an excursion of the mind instead.

One
THE SOUTH SIDE

Chicago's South Side is home to a diverse group of monuments, markers, and memorials. The State Line Monument that was erected in 1838 is believed to be both the city's oldest monument and oldest structure. The Andreas Von Zirngibl memorial is certainly a contender for the most unusual monument, because of its location in the middle of a scrap yard. The Confederate Mound at Oak Woods Cemetery marks the grave of over 6000 Confederate Civil War soldiers who died in Chicago while being held as prisoners of war, and the Balbo Monument is a fragment of an original structure that stood in Italy nearly two thousand years ago.

The South Side is also home to several memorials that honor the men and women who gave their lives to protect our city and our country. At 35th Street and Michigan Avenue, in the new Police Headquarters Building, is the Superintendent's Honored Star Case that contains the badges of the nearly 500 Chicago Policemen who have been killed in the line of duty. At 558 W. DeKoven in the Chicago Fire Department's Training Academy is the Honor Star Case which contains the badges of the nearly 600 Chicago firemen killed in the line of duty. And last, at 18th Street and Michigan Avenue is the *Above and Beyond* Memorial inside the National Vietnam Veterans Art Museum which displays a dog tag for each of the 58,000 soldiers killed in the Vietnam War.

There are a number of statues that honor the accomplishments of many individuals. The Drake fountain honors the explorations of Christopher Columbus. The Lincoln monument in Oak Woods Cemetery pays tribute to the great emancipator and his delivery of Gettysburg Address. George Washington is honored with a monument as he takes command of the American Revolutionary War forces in Cambridge, Massachusetts on July 3, 1775, and Stephen Douglas is memorialized with an enormous monument that recalls his extraordinary contributions.

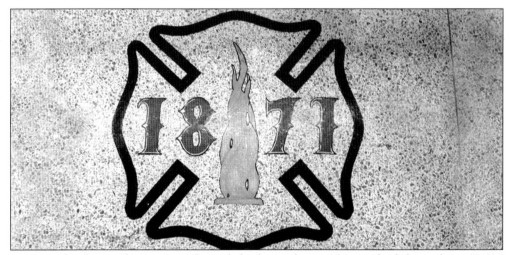

In 1871, the Great Chicago Fire claimed the lives of over 250 people, left another 100,000 homeless, destroyed 18,000 buildings, and caused over $200 million in damage to property. The fire started in Mrs. Catherine O'Leary's barn at 558 W. DeKoven Street. Ironically, the Chicago Fire Department's Training Academy now stands on the site. On the floor of the Academy, there is a memorial placed at the very spot where the Great Chicago Fire started. The memorial is engraved with a symbol of a flame and the year 1871, which marks the date of the great conflagration.

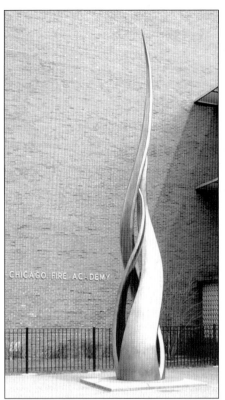

The 30-foot-high bronze *Pillar of Fire* by sculptor Egon Weiner (1906–1987) sits in front of the Chicago Fire Department's Training Academy near the spot where the Chicago Fire began on that fateful day. The inscription at the base of the sculpture reads: "Here Began the Chicago Fire of 1871." The memorial was unveiled in 1961 and the site was designated a Chicago landmark on September 15, 1971. There are other sculptures by Weiner displayed throughout the city, but this is undeniably his most famous work.

One of the city's most moving and stirring monuments is the Chicago Fire Department's Honor Star Case. This case displays the badges of nearly 600 Chicago firemen killed in the line of duty. In front of the memorial are the actual boots worn by several of the firefighters who perished. The monument was funded in part by Hollywood actor and producer Ron Howard and his company Imagine Entertainment. After the completion of the movie *Backdraft* (filmed primarily in Chicago), Howard showed his appreciation to the city and the fire department by generously supporting this project at the Fire Academy.

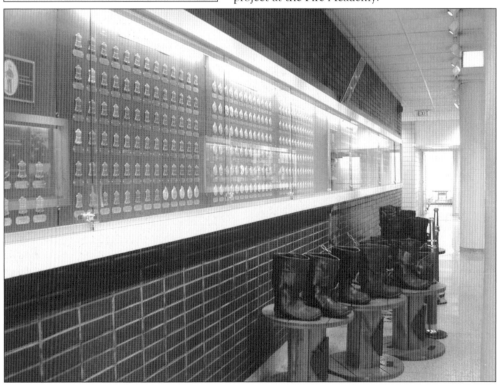

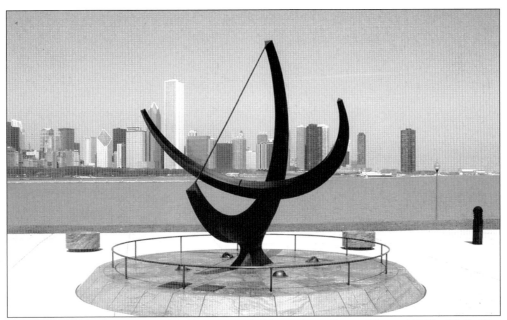

Man Enters the Cosmos is a 13-foot bronze sundial by sculptor Henry Moore (1898–1986). The work was created to honor what scientists consider the "golden years of astronomy." During the 50-year period between 1930 and 1980, astronomers' knowledge of the universe was immensely expanded. The work was commissioned by the trustees of the B.F. Ferguson monument fund. It was unveiled in front of the Adler Planetarium in 1980. The Chicago skyline provides the perfect backdrop for this sculpture.

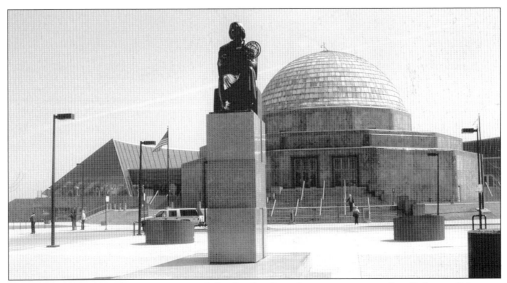

In honor of the 500th anniversary of the birth of modern astronomy, this 9-foot-tall bronze statue of Nicholas Copernicus (1473–1543) was prominently placed in front of the Adler Planetarium on Solidarity Drive. The statue features Copernicus holding a compass and a model of the solar system while gazing up toward the heavens. It is a bronze reproduction of the original statue that was created in 1823 by sculptor Bertel Thorvaldsen (1770–1844). The statue was unveiled on October 14, 1973.

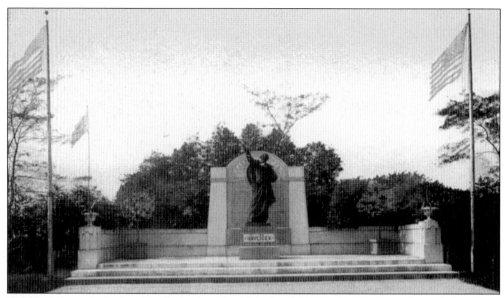

This bronze work depicts Czech patriot Karel Havlicek (1820–1856), dressed in a full military uniform and draped cape, with his arm outstretched. It is the work of sculptor Joseph Strachovsky, who was commissioned by Chicago's Bohemian-American community to create the work. The unveiling in 1910 was attended by a crowd of nearly 20,000. The memorial was placed originally in Douglas Park where this photograph was taken around 1912. It was removed from the park in 1981, and now stands on Solidarity Drive.

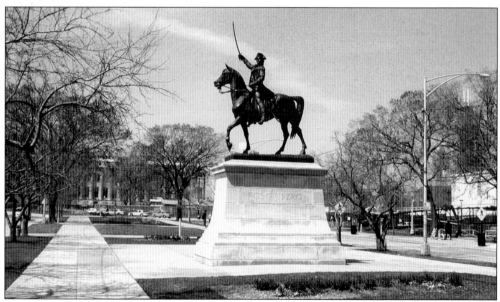

Pictured here is a bronze statue of Thaddeus Kosciuszko (1746–1817) sitting atop his horse. It originally stood in Humboldt Park on Chicago's West Side. When it was unveiled in 1904, over 100,000 people attended the ceremony. In 1978, the statue was moved to its current location on Solidarity Drive near the Adler Planetarium. Kosciuszko was a war hero in his native Poland, as well as in the United States, where he fought for the American Revolution. The statue is the work of sculptor Kasimir Chodzinski (1861–1920).

14

Overlooking the lakefront, between the Field Museum and Soldier Field, is the Gold Star Families Memorial Park. The park is a tribute to all of the Chicago police officers who have been killed in the line of duty. There are over 460 crab trees in the park—one for each officer who was killed while protecting the city. The park was dedicated in a ceremony on September 23, 2000; Mayor Richard M. Daley, Police Superintendent Terry Hillard, and the families of many of the slain officers attended. This marker can be found near the entrance to the park.

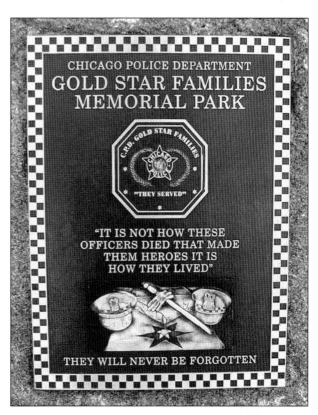

Standing in the shadow of Soldier Field is the Balbo Monument. The monument, which was a gift from Italy, was erected to honor Italian General Italo Balbo (1896–1940). On July 1, 1933, Balbo led a squadron of 24 planes on a 6,100 mile journey from Italy to the Century of Progress Exposition in Chicago. In 1934, on the first anniversary of the great aviation feat, Seventh Street was renamed Balbo Drive. The marble column is a fragment of an original structure that stood in Italy nearly two thousand years ago.

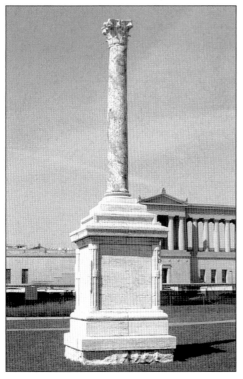

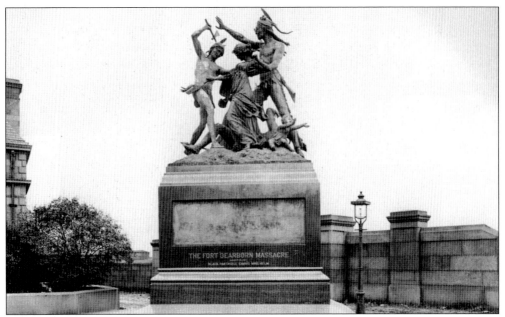

There is probably no other statue in Chicago that has terrified children quite like *Massacre Monument*. This large bronze sculpture is the work of Carl Rohl-Smith (1848–1900) and was unveiled on June 22, 1893, in front of a large group of dignitaries that included many famous Chicagoans, U.S. Supreme Court Chief Justice Melville Fuller, and former U.S. President Benjamin Harrison. The photo dates back to the time when this work was originally placed in front of the home of George Pullman, near the actual spot where the massacre took place. It has been moved several times since then and is currently in storage.

Above and Beyond is a memorial to the members of the United States Armed Forces who lost their lives in the Vietnam War. This massive 10 by 40 foot memorial, which hangs from the ceiling of the National Vietnam Veterans Art Museum at 1801 S. Indiana, contains 58,000 dog tags, one for each of the men and women who lost their lives in the conflict. The tags reveal the names of all the soldiers, their branch of service, and the date they were killed. The memorial was unveiled on May 26, 2001.

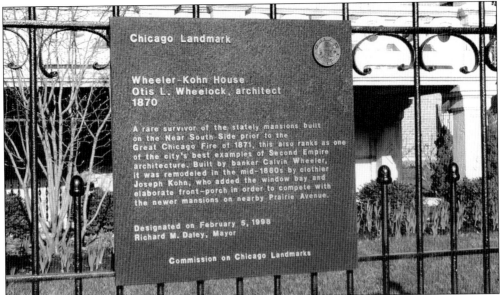

This marker honors the Wheeler-Kohn home at 2018 S. Calumet Avenue, which architect Otis. L. Wheelock built in the 1860s for the prominent Chicago banker, Calvin T. Wheeler. It was remodeled in 1885 by its second owner, Joseph A. Kohn, a successful clothier. It is a rare surviving mansion from Chicago's pre-fire days and a great example of Second Empire Architecture. The home has been completely restored and now serves as one of the city's most luxurious bed and breakfasts. It was designated as a Chicago Landmark on February 5, 1998.

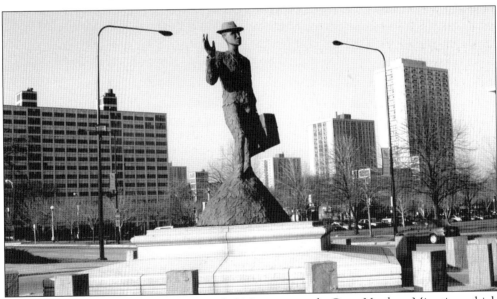

Pictured here is a 15-foot-tall statue entitled *Monument to the Great Northern Migration*, which stands in the middle of a small traffic island at 2620 S. Martin Luther King Drive. It has been estimated that between 1900 and 1950, over 120,000 African-Americans migrated from the South to Chicago. This statue, which features a man carrying a suitcase and heading north, is a testament to that long and often difficult journey. The monument is the work of Los Angeles sculptor Alison Saar (b. 1956).

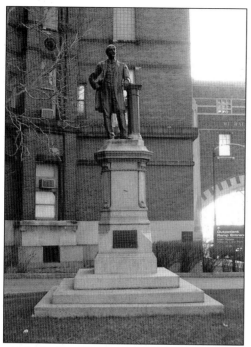

This bronze statue of Michael Reese (1817–1877) stands on a large pedestal in front of the hospital that also bears his name—although Reese was never a doctor and never lived in Chicago. He was a philanthropist who made his fortune in land speculation, and he donated enormous amounts of money to various charitable institutions. He gave generously to his relatives, and two of his nephews founded a hospital on the South Side of Chicago and named it in his honor. They also commissioned sculptor Richard Henry Park (1832–1902) to build a statue of their uncle in front of the hospital at 29th Street and Ellis Avenue.

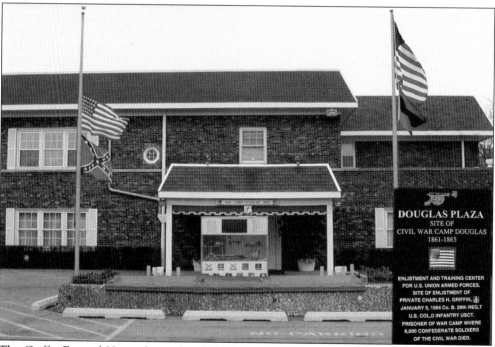

The Griffin Funeral Home, located at 3232 S. Martin Luther King Drive, stands on a portion of the old Camp Douglas. Many African-American soldiers, including Captain Ernest A. Griffin, were inducted to serve in the Civil War at this location. The owner of the funeral home is a direct descendant of Captain Griffin and has erected this memorial to honor him. The memorial consists of documents, photos, battle logos, flags, weapons, and various other items that relate to the captain's life.

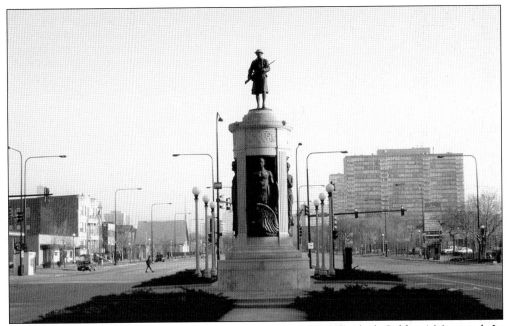

In 1927, the State of Illinois erected *Victory*, the World War I Black Soldiers' Memorial. In 1936, the figure of a striding "doughboy" was added to the top of the column. Three bronze panels circle the monument's shaft: a black solder, a black woman symbolizing motherhood, and Columbia holding a tablet that lists the battles of the regiment. The memorial was sculpted by Leonard Crunelle (1872–1944), and it is located in the Bronzeville neighborhood at 35th Street and Martin Luther King Drive.

This memorial at 3050 South Lowe Avenue honors James A. Humbert (1924–1945), a Chicagoan who served in the U.S. Navy and was killed in action during World War II. Friends and relatives never forgot Humbert, and for years sought a way to honor him. In 1999, the Chicago City Council passed an ordinance that renamed Lowe Park in honor of Humbert. This memorial to Humbert was unveiled the same year the park was renamed.

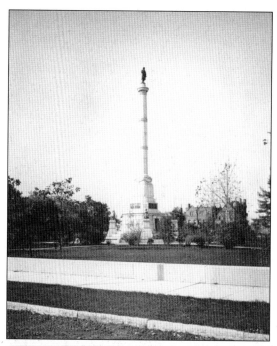

The Stephen A. Douglas tomb and monument located at 35th and Cottage Grove is one of Chicago's oldest and tallest memorials. Built on land that was once part of the Douglas estate, the 100-foot-tall monument was completed in 1881. It is the work of sculptor Leonard Wells Volk (1828–1895). The monument and the small park surrounding it are maintained by the State of Illinois, and the area is officially known as the Douglas Tomb State Memorial Park. This photograph dates back to 1888.

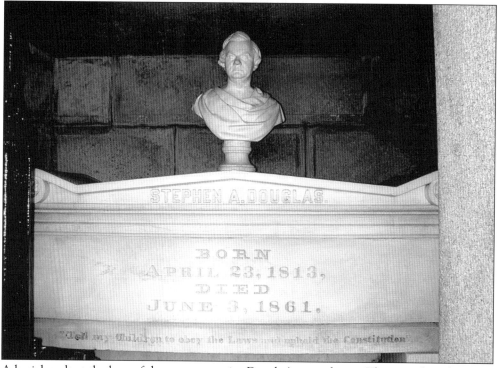

A burial vault at the base of the statue contains Douglas's sarcophagus. The epitaph on his tomb reads: "Tell my children to obey the laws and uphold the Constitution." Douglas was a very early Chicago resident, having moved to the city in 1847. Although he had been soundly defeated in the 1860 presidential election by Abraham Lincoln, he was still considered one of the country's most powerful and popular political leaders of his day.

Visitors to the new Chicago Police Headquarters at 3510 S. Michigan Avenue are greeted by this large monument on the exterior of the building. It is an oversized replica of a Chicago Police badge with the centerpiece of the five point star containing the seal of Chicago. The shield symbolizes the national spirit of Chicago, the Indian represents the first discoverers of Chicago, the ship in full sail signifies the approach of civilization and commerce, the sheaf

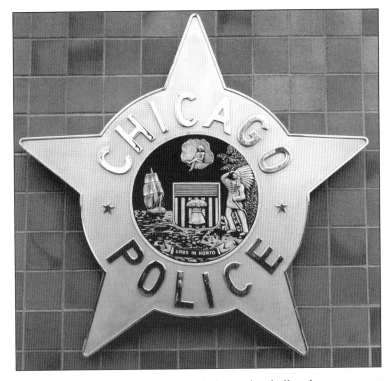

of wheat embodies activity and natural abundance, and the babe in the shell is the ancient and classical symbol of the pearl, signifying Chicago as the "gem of the lakes."

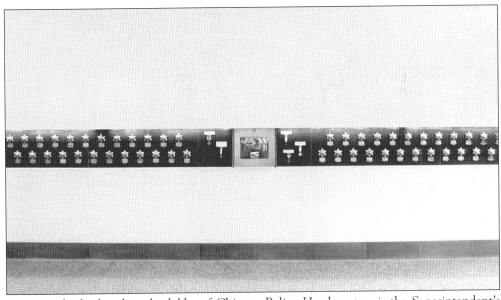

Prominently displayed in the lobby of Chicago Police Headquarters is the Superintendent's Honor Star Case. Considered by many to be one of the city's most sacred monuments, it contains the badges of the Chicago Police officers killed in the line of duty since 1854, which totals nearly 500. The memorial is built directly into the walls of the building, in four separate sections, and there is also an interactive video which honors the fallen heroes.

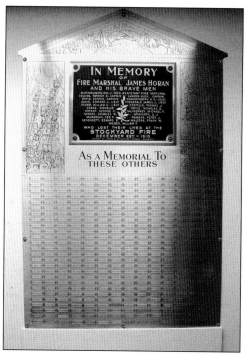

On December 22, 1910, a horrific fire broke out in Warehouse No. 7 of the Nelson Morris & Company Plant (1400 W. 43rd Street) located inside the Union Stock Yards. Fifty engine companies and seven hook and ladder companies were called out to help extinguish the blaze. As the firefighters were attempting to put out the fire, an overhead canopy collapsed upon them. Twenty-one firemen and three civilians became buried in rubble so hot that they were unable to be rescued. This memorial to the men killed in the Stock Yards' Fire hangs in the lobby of the Fire Commissioner's office at 10 West 35th Street.

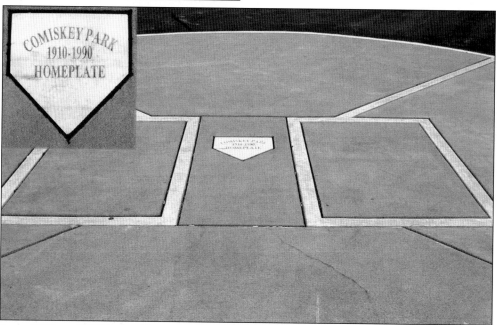

From 1910 until 1990, the Chicago White Sox played their home games at old Comiskey Park. The Park which was located at 35th & Shields, and was named in honor of Charles A. Comiskey (1859–1931), the owner and president of the White Sox from 1900 until 1931. The ballpark was built by architect Zachary Taylor Davis (1872–1946), who also built Wrigley Field. It was razed after the completion of the 1990 season. Today, all that remains is a marble replica of home plate embedded in asphalt. The marker allows fans to stand in the exact spot where many baseball greats (including Babe Ruth, Ty Cobb, and Ted Williams) took their swings.

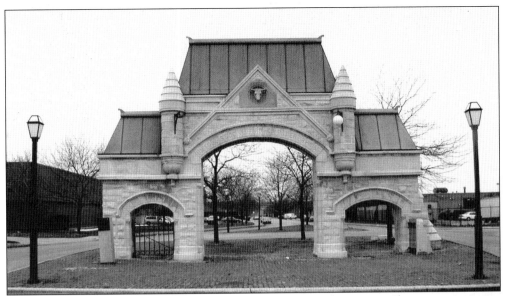

From its inception in 1865 until its closing in 1971, the Union Stockyards was one of the largest and most famous livestock and meat packing operations in the world. It is estimated that over one billion animals were slaughtered there, earning Chicago the title, given by Carl Sandburg, of "hog butcher to the world." Today, all that remains of the 475-acre complex is the triple-arched limestone entrance gate with its copper roof designed by architects Daniel Hudson Burnham and John Wellborn Root. The Union Stock Yards Gate is located at 850 W. Exchange Avenue. In 1972, it was designated as a Chicago landmark.

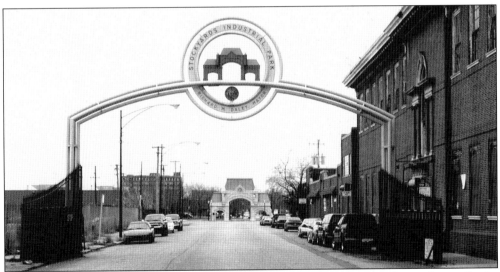

At Halsted Street and Exchange Avenue, viewers can find this giant steel sculpture that marks the entrance to the Stock Yards Industrial Park. The centerpiece of the sculpture is a scale model of the old limestone entrance to the Stock Yards. (The original limestone entrance is still standing and can be seen in the background of this photograph.) When the Yards closed in 1971, the vacant area was redeveloped into an industrial park. Despite some environmental issues, the Stock Yards Industrial Park has attracted many businesses and become a success. This steel sculpture was erected in the mid 1990s by Mayor Richard M. Daley and local leaders, to stimulate economic growth.

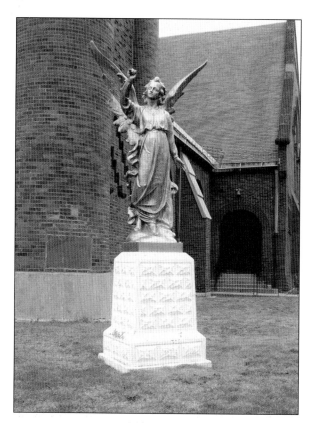

This bronze statue of Saint Gabriel is located at 4501 South Lowe Avenue, where it stands in front of the church of the same name. The church, which was designed in 1887 by two of Chicago's most famous architects, Daniel Hudson Burnham (1846–1912) and John Wellborn Root (1850–1891). The architectural firm of Burnham & Root designed some of the most famous buildings in early Chicago history, including the Rookery and the Monadnock Building. Saint Gabriel's Church is listed on the National Register of Historic Places.

The David Wallach Fountain can be found in Burnham Park near Promontory Point. Sitting atop the marble fountain is a small but elegant bronze fawn curled up in a fetal position. The fountain is the work of Elizabeth Haseltine Hibbard (1889–1950) and her husband Frederick Cleveland Hibbard (1881–1955). The fountain is the posthumous gift of David Wallach, who died in 1894 and left a bequest in his will for the creation of the fountain. For reasons that are unclear, the request went unfulfilled until the fountain was unveiled some 45 years later, in 1939.

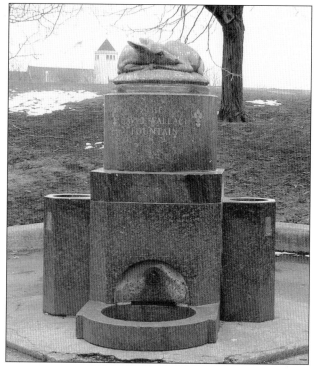

This memorial boulder honors the "Father of Hyde Park," Paul Cornell (1822–1904). As a member of the South Park Board of Commissioners, he promoted the expansion and creation of Chicago parks. In fact, this boulder at 5200 S. Hyde Park Boulevard sits on land that Cornell donated for use as a park in 1856. There are several other memorials to Cornell in the area, including a street and a park that are both named for him. A giant memorial in Oak Woods Cemetery marks his burial place.

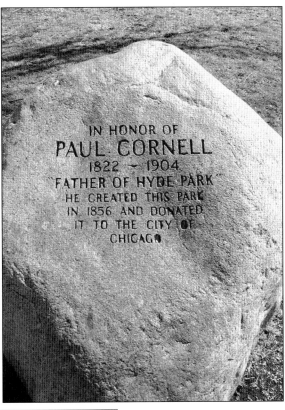

IN HONOR OF
PAUL CORNELL
1822 – 1904
"FATHER OF HYDE PARK"
HE CREATED THIS PARK
IN 1856 AND DONATED
IT TO THE CITY OF
CHICAGO

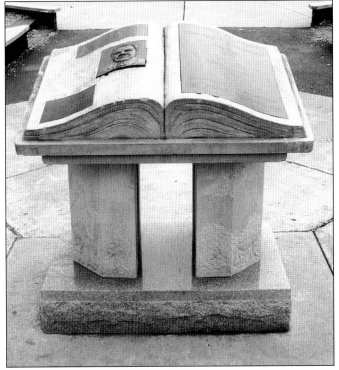

Pictured here is a monument to Harold Washington. It is located in the small children's playground section of Washington Park at 5200 S. Hyde Park Boulevard. Resting on a small granite pedestal, the limestone and bronze sculpture is designed in the shape of a book. The pages of the book feature small bronze plaques which honor the former Chicago mayor's accomplishments. Washington lived just a short distance from where the monument now stands. The memorial is the work of sculptor Walter S. Arnold, who also completed another monument to Harold Washington that can be found at 600 W. Madison.

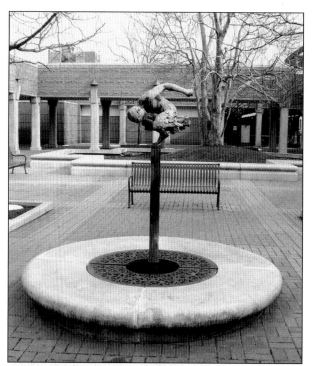

This work entitled *Jacob and the Angel II* can be found in a small courtyard of the Hyde Park Shopping Center, at East 55th Street and Lake Park Avenue. The small bronze work features the biblical Jacob struggling with an angel sent by God to test his worthiness to lead the Jews. The work was donated by a group of local Hyde Park residents. Unveiled in 1961, it is the work of renowned sculptor Dr. Paul Theodore Granlund (b. 1925). Granlund's works can be found throughout the United States, but the majority are located in his home state of Minnesota.

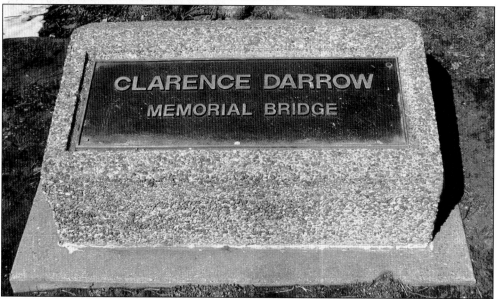

Clarence Seward Darrow (1857–1938) is considered by many to be one of the most successful criminal defense attorneys in the history of the United States. A staunch opponent of the death penalty, he utilized his tremendous courtroom skills to defend over 100 people charged with murder, and none of those he defended were sentenced to death. His most sensational case was the 1924 murder trial of Nathan Leopold and Richard Leob. Darrow lived in Hyde Park, and after his death, his ashes were scattered in the Jackson Park Lagoon. On May 1, 1957, this bridge behind the Museum of Science and Industry was renamed the Clarence Darrow Memorial Bridge in his honor.

Standing in Jackson Park is one of sculptor Daniel Chester French's (1850–1931) most impressive works, known as *The Republic*. This 24-foot-high statue, which was unveiled in 1918, is actually a replica of the original that stood in the Court of Honor at the World's Columbian Exposition of 1893. French's original work (which was 65 feet high and standing on a base that was 35 feet high) was destroyed after the completion of the fair. The ornate pedestal for this work was designed by Henry Bacon (1866–1924).

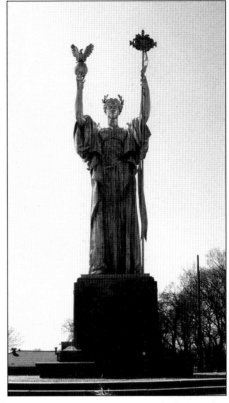

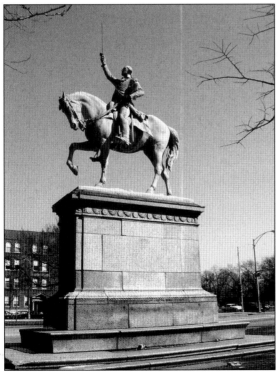

The George Washington Memorial stands near the north entrance of Washington Park at 51st and Martin Luther King Drive. This magnificent statue is the work of sculptors Daniel Chester French (1850–1931) and Edward Clark Potter (1857–1923). The sculptors actually made two copies of this statue. The original, which was unveiled on July 4, 1900, stands in Paris, France. The Chicago version (which sits on a red granite pedestal) was unveiled in 1904 at an elaborate dedication ceremony.

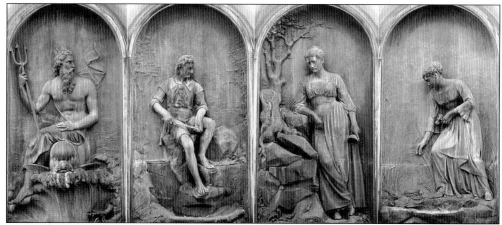

These are photographs of the four decorative relief panels found on the base of the Drexel Fountain. All of the reliefs picture water themes. The panel on the left features the Roman God of the sea (Neptune) riding a dolphin, the second depicts a young man fishing, the third shows a young maiden standing at a spring with a goblet in her left hand, and the fourth features a beautiful young girl picking flowers at the water's edge. The statue and the relief panels were cast entirely in bronze by the Charles F. Heaton Company in Philadelphia and then shipped to Chicago.

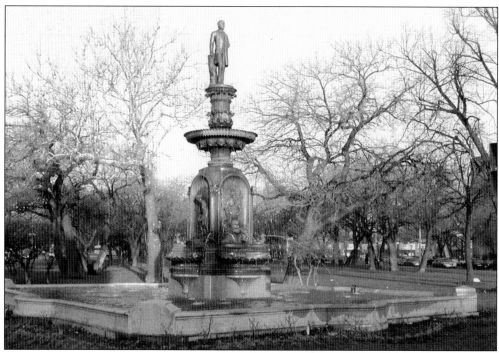

The Drexel Fountain was erected to honor the memory of Francis Martin Drexel (1792–1863). The memorial was commissioned by Drexel's two sons, Francis A. and Anothy Drexel. Located at 51st and Drexel Boulevard, it is the work of sculptor Heinrich (Henry) Manger (b. 1833). Unveiled in 1882, it is believed to be the oldest existing fountain in the City of Chicago, and certainly one of the most elegant and exquisite fountains to be found anywhere. In the year 2000, the fountain was completely restored and rededicated at a ceremony attended by Mayor Richard M. Daley.

This statue pays tribute to one of the most influential figures of the Enlightenment. Gotthold Ephraim Lessing (1729–1781) was a German philosopher, author, dramatist, and critic. This bronze statue of Lessing was unveiled in 1930 and can be found in Washington Park at 55th Street and Cottage Grove Avenue. It is the work of sculptor Albin Polasek (1879–1965), whose other works can be found throughout the city. The statue was a gift of Chicagoan Henry L. Frank (1839–1926), a nephew of Michael Reese.

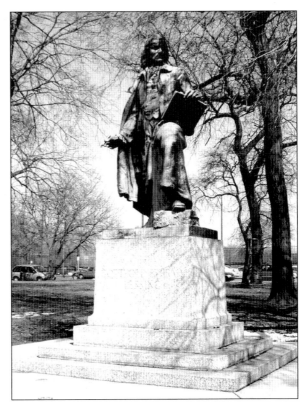

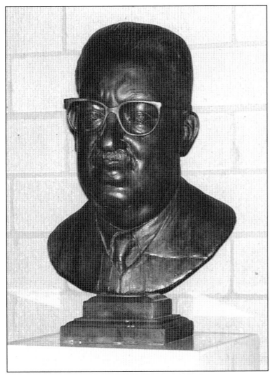

Thurgood Marshall (1908–1993) is considered by many to be one of the greatest liberal jurists of our time. As chief counsel for the NAACP, he argued and won many cases which promoted civil rights. His most famous case, Brown v. Board of Education, resulted in declaring racial segregation in public schools unconstitutional. In 1967, he became the first African-American Supreme Court Justice. This bust of Marshall is the work of sculptor Erik Blome. It was completed in 1996 and unveiled in a ceremony led by Mayor Richard M. Daley. The bust can be found in the lobby of the Thurgood Marshall library at 7506 S. Racine Avenue.

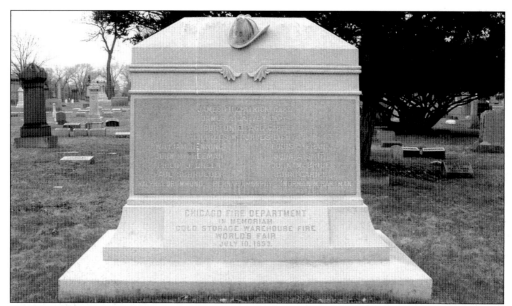

On July 10, 1893, firefighters were called in to fight a blaze at 64th and Stony Island Avenue. A fire had broken out in a six-story cold-storage warehouse that had been built to store perishable food items for the Chicago World's Fair. The blaze had started in a faulty chimney inside a 200-foot-high wooden tower, and as the firemen raced up the tower to extinguish it, they became trapped 200 feet above the street. The fire quickly spread and cut off their escape route, and 17 firemen were killed when they either jumped or fell to their deaths. This monument at Oak Woods Cemetery (with the Chicago Fire Department hat resting upon it) honors the courageous men.

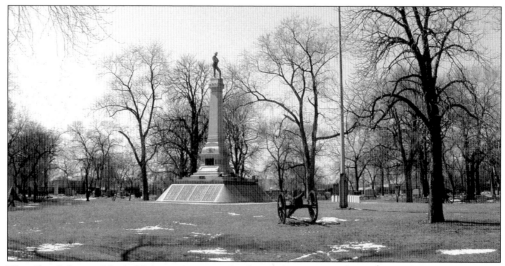

The Confederate Mound Monument stands above the graves of 6,000 Confederate prisoners who died at Camp Douglas during the Civil War. It was dedicated on Memorial Day of 1895. The graves were placed in concentric trenches around the monument. Although the individual graves were never marked, in 1911 the names, companies, and regiments of the 4,275 men (identified from official records) were added on bronze tablets. The artist is unknown, but the design was based on a painting by John A. Elder (1833–1895). The monument is located at 1035 E. 67th Street, inside Oak Woods Cemetery.

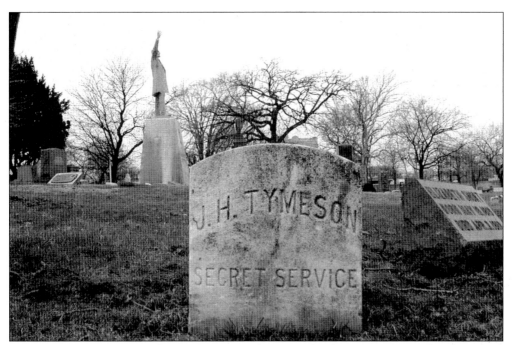

This simple monument at Oak Woods cemetery honors early Chicago resident and United States Secret Service agent John Henry Tymeson (1836–1915). The Secret Service was established in 1865, and Tymeson was one of the first agents from the Chicago area to serve on the force. He was also a Civil War veteran, and is buried in a section of the cemetery that is reserved for Union soldiers. The statue of Abraham Lincoln can be seen standing in the background.

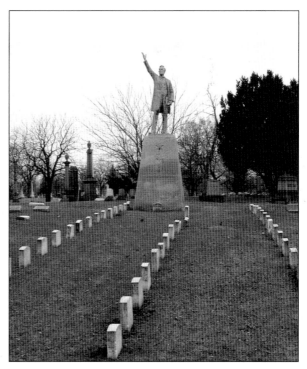

This statue, which is known as *Lincoln the Orator* or *The Gettysburg Lincoln*, is a replica of the original that stands in Pana, Illinois. Both are the work of sculptor Charles J. Mulligan (1866–1916). The statue portrays Lincoln as he is delivering his famous Gettysburg Address, and it stands in sharp contrast to most Lincoln statues which feature him in much more subtle poses. This 11-foot-tall bronze sculpturewas placed in Oak Woods Cemetery by a local chapter of the Grand Army of the Republic in 1905.

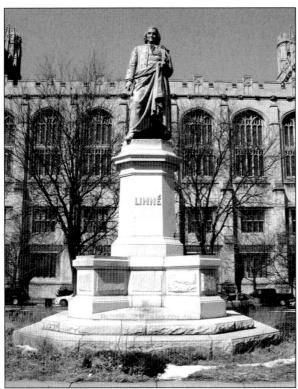

This is a large bronze statue of Swedish botanist Carl von Linne (1707–1778). It stands on the Midway Plaisance and is the work of sculptor Johan Dyfverman (1844–1892). The monument is a copy of the original that can be found in the Royal Gardens at Stockholm. This statue was unveiled in 1891 and originally stood in Lincoln Park. It was moved to its present location and rededicated in an elaborate ceremony that was attended by the King of Sweden and other dignitaries in 1976.

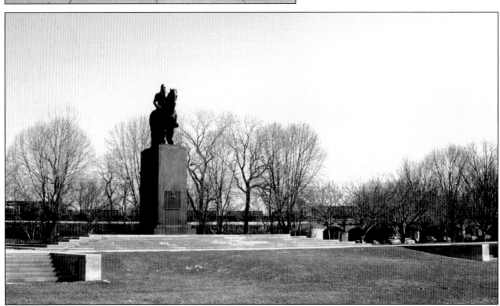

The Thomas G. Masaryk Monument was dedicated in 1955. It is an 18-foot-high bronze sculpture of medieval knight Saint Wenceslaus. It sits atop a 20-foot-high massive granite pedestal that measures 84 by 64 feet at its base. The statue was erected to honor the memory of Thomas G. Masaryk (1850–1937), who was Czechoslovakia's first president and, for a brief period, a professor at the University of Chicago. The work is located on the university campus at the east end of the Midway Plaisance. It is the work of sculptor Albin Polasek (1879–1965).

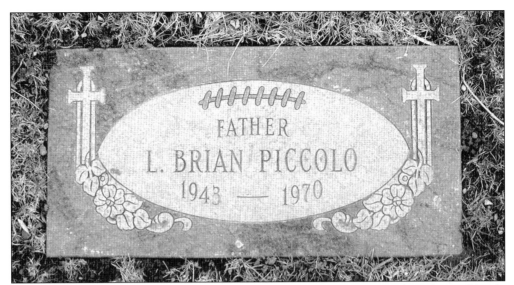

One of the most heart-wrenching stories in the history of Chicago sports is that of Brian Piccolo (1943–1970). Piccolo and his good friend Gale Sayers were running backs for the Chicago Bears. (Piccolo stood in his friend's shadow until Sayers injured his knee during the 1968 season). Piccolo filled in for Sayers and quickly became a fan favorite. Unfortunately, he was soon diagnosed with embryonal cancer and died on June 16, 1970 at the age of 26. The real tragedy is that today, this type of cancer has a cure rate of over 90 percent. Piccolo's life story was made into a movie, *Brian's Song*. He is buried here at St. Mary's Cemetery at 87th and Hamlin Avenue, where fans and friends of Piccolo often leave footballs on his headstone.

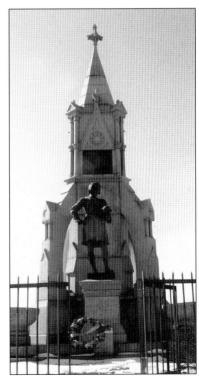

The Drake Fountain is one of the few works in Chicago that is named for the person who funded it instead of the person who is featured in it. Commissioned by early Chicago hotel mogul John B. Drake, this fountain (which features Christopher Columbus) was unveiled in 1893. The fountain originally stood in the Loop near City Hall, but was moved in 1909 to its present location in the middle of an intersection at 92nd and Exchange Avenue. This Gothic-style fountain is the work of sculptor Richard Henry Park (1832–1902).

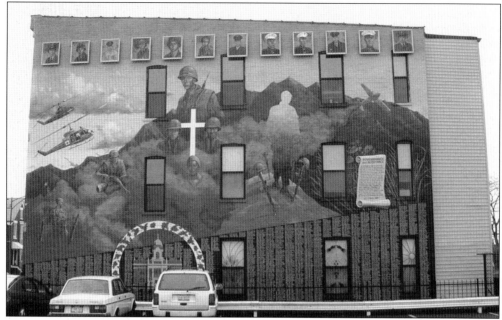

This mural at 9108 S. Brandon is a memorial to the 12 parishioners from Our Lady of Guadalupe Church who were killed while serving in the Vietnam War. The parish lost more men in Vietnam than any other church in the country. The mural, entitled *Remembrance and Acceptance*, features portraits of the fallen soldiers. The work, which was officially unveiled on September 24, 2000, is the work of artists from the National Vietnam Veterans Art Museum at 1801 S. Indiana Avenue. Another granite memorial to the 12 soldiers can be found at 9100 S. Brandon.

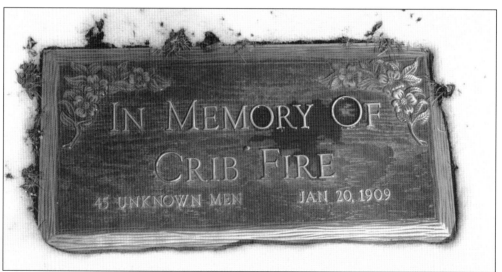

On the morning of January 20, 1909, 60 men were killed in a fire at the 68th Street Water Crib. The wooden crib was located in Lake Michigan about one mile from shore, and it housed scores of workers who were building a tunnel below the lake. A number of men were saved by jumping into the frigid water where they clung to floating ice until help arrived. The cause of the fire was never determined. This monument at Mount Greenwood Cemetery, 111th Street and California Avenue, contains the bodies of 45 of the workers who perished.

This monument in Mt. Olivet Cemetery marks the grave of Mrs. Catherine O'Leary (1827–1895). Legend has it that her cow allegedly kicked over the lantern that started the Great Chicago Fire. Her son James Patrick "Big Jim" O'Leary (1862–1925) is also buried there, as are other members of the O'Leary family. "Big Jim" was the gambling king of Chicago and he ran an illegal gambling empire out of his saloon at 4183–85 S. Halsted Street, which was located directly across the street from the main entrance to the Union Stockyards. Part of the building still stands today and is operated as a hardware store. Big Jim's mansion at 726 W. Garfield Boulevard still stands as well.

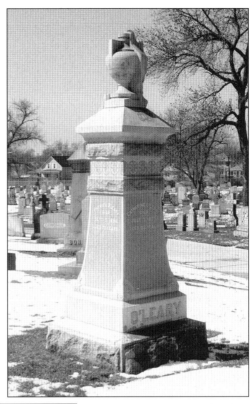

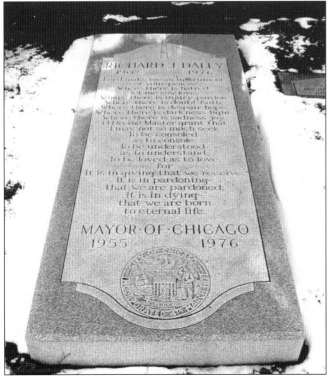

This monument to Mayor Richard J. Daley can be found in Holy Sepulchre Cemetery at 6001 W. 111th Street. This serene and tranquil location seems to be the perfect final resting place for the Mayor and other members of his family. An elegant granite memorial bearing the seal of Chicago and an inscription of the Prayer of St. Francis marks the Mayor's grave, while a large Celtic cross stands behind the memorial. According to officials at the cemetery, the Mayor's grave is one of the most visited sites—a fact which testifies to Richard J. Daley's popularity.

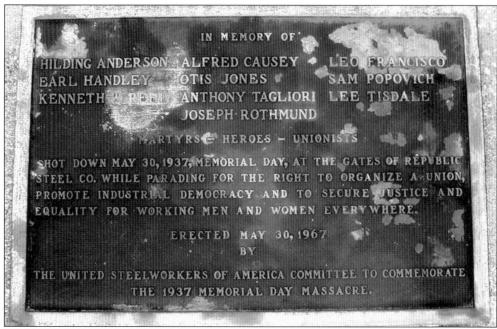

IN MEMORY OF

HILDING ANDERSON ALFRED CAUSEY LEO FRANCISCO
EARL HANDLEY OTIS JONES SAM POPOVICH
KENNETH W. REED ANTHONY TAGLIORI LEE TISDALE
JOSEPH ROTHMUND

MARTYRS - HEROES - UNIONISTS

SHOT DOWN MAY 30, 1937, MEMORIAL DAY, AT THE GATES OF REPUBLIC
STEEL CO. WHILE PARADING FOR THE RIGHT TO ORGANIZE A UNION,
PROMOTE INDUSTRIAL DEMOCRACY AND TO SECURE JUSTICE AND
EQUALITY FOR WORKING MEN AND WOMEN EVERYWHERE.

ERECTED MAY 30, 1967
BY

THE UNITED STEELWORKERS OF AMERICA COMMITTEE TO COMMEMORATE
THE 1937 MEMORIAL DAY MASSACRE.

On the afternoon of Memorial Day, May 30, 1937, hundreds of striking steel workers and their sympathizers gathered to protest the labor actions of the Republic Steel Corporation. After a series of speeches, the crowd crossed the street and began heading through an open prairie toward the Republic Steel Mill. The demonstrators were met by Chicago police who had been ordered to protect the mill. The confrontation quickly turned violent, and when the smoke cleared, ten demonstrators were dead and scores more were injured. This monument next to the labor hall at 11731 Avenue O serves as a memorial to the dead.

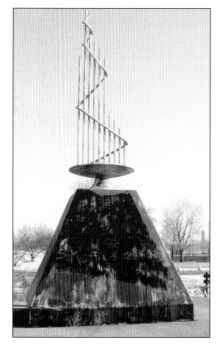

The Republic Steel Sculpture is only one of a handful of sculptures on Chicago's Southeast Side. The work consists of six long bars that represent Republic Steel's six districts, four short bars that represent the cardinal compass points from the plant to the community, and a spiral bar which symbolizes the relationship between the company and its neighbors. It sits in a circular dish atop a large black granite pedestal. The sculpture is located on 116th Avenue between Avenue O and Green Bay Avenue.

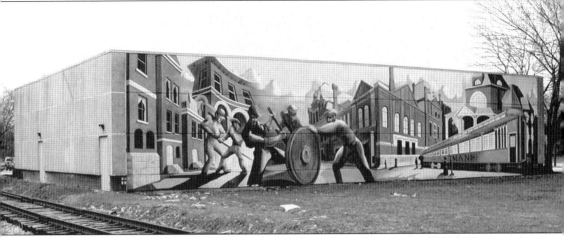

The historic Pullman Foundation Visitor Center is located on the corner of 112th Street and Cottage Grove Avenue. This mural entitled *Visual Interpretations of Pullman* can be found on the north exterior wall of the building. The mural features the Pullman Palace Car, company workers, the former Pullman Arcade Building, and other views of the Town of Pullman. Completed in 1996, the giant and colorful mural is the work of students from the American Academy of Art.

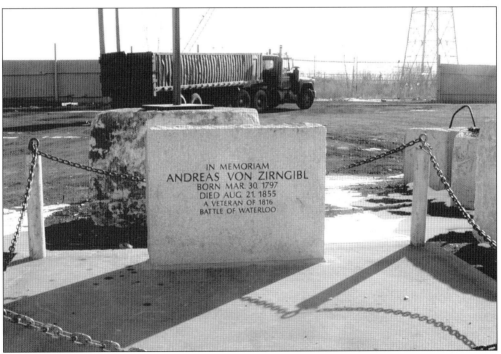

The memorial honoring Andreas Von Zirngibl (1787–1855) is perhaps one of the most unusual in all of Chicago. Von Zirngibl was a one-armed fisherman who emigrated from Germany to Chicago in 1854. Shortly thereafter, he purchased a 40 acre tract of land at the mouth of the Calumet River. When Von Zirngibl purchased the land, he declared that upon his death he wished to be buried there, no matter what happened to it. The following year, 1855, he died and was buried there. Today the land is owned by a large scrap company and Von Zirngibl is buried "smack dab" in the middle of the scrap yard.

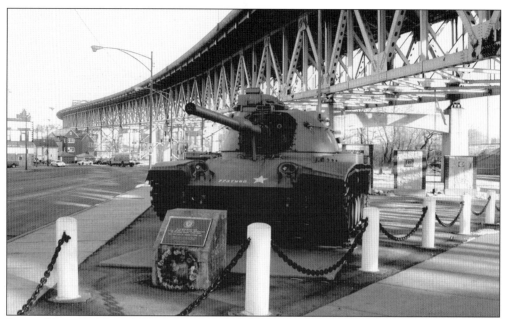

Pictured here is a United States Army tank which is the centerpiece of the East Side Memorial Park. This small triangular park—found at the intersection of Ewing Avenue and Indianapolis Boulevard at 100th Street—was erected to honor veterans of the 10th Ward in 1979. The tank and the massive Chicago Skyway Bridge behind it also serve as memorials to the area's steelmaking industry. Before most of the steel companies closed down or moved away from this area, they produced army tanks and materials for bridges like the one seen in the background.

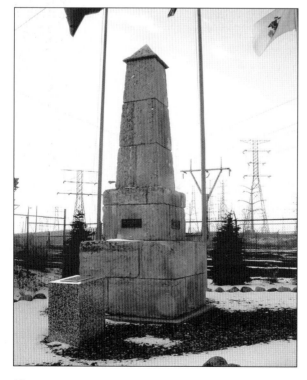

Erected in 1838, the Illinois State Line Monument is the oldest existing structure in Chicago. The 15 foot stone obelisk was erected as a boundary marker to establish a border between Illinois and Indiana. The monument, which is made of solid sandstone blocks and reinforced with interior iron straps, was commissioned by the Office of the United States Surveyor General. The monument is located in front of the Commonwealth Edison State Line Generating Plant at 4001 E. 102nd Street.

Two

THE WEST SIDE

Although the West Side does not contain as many monuments, markers, and memorials as other sections of the city, there are still many outstanding works to be appreciated. One of the most significant of these works is the Haymarket Riot Monument located at the Chicago Police Training Academy. This memorial recalls the Haymarket tragedy in 1886 in which eight policemen and two civilians were killed. Also found on the West Side are one of the city's only monuments to Dr. Martin Luther King Jr., and the Vietnam Survivor's Memorial, which pays tribute to the men and women who served in the U.S. Armed Forces during the conflict.

The West Side is home to a number of monuments that honor sporting legends. A memorial to baseball great Joe DiMaggio can be found on Taylor Street in the Little Italy neighborhood. Another monument designed by sculptor Erik Blome honoring the Chicago Blackhawks can be found on Madison Street in front of the United Center. Perhaps the most popular statue in all of Chicago, also located at the United Center, honors basketball star Michael Jordan. There is also a monument to Michael Jordan's father, James Jordan, on the West Side.

The largest concentration of statues in this section of the city can be found in Garfield and Humboldt Parks. Garfield Park contains a statue of Scottish poet Robert Burns, as well as a monument to Abraham Lincoln. In addition, the Garfield Park Conservatory contains two sculptures by Lorado Taft and one by Ida McCelland Stout entitled *Charitas*. In nearby Humboldt Park, there are several more, including a memorial to Leif Ericson, a statue of Fritz Reuter, and creations by sculptors Charles J. Mulligan and Edward Kemeys.

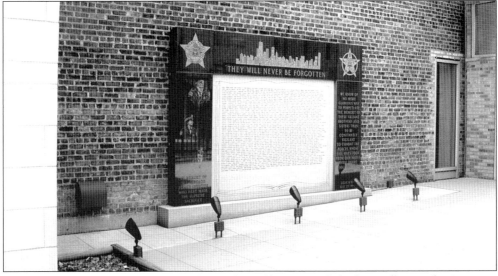

This granite memorial to Chicago's slain police officers, entitled *They Will Never be Forgotten*, is located at the Fraternal Order of Police Lodge #7, 1412 W. Washington Boulevard. Unveiled on May 29, 1998, the memorial is engraved with the names of nearly 500 Chicago Police officers who lost their lives in the line of duty. Engraved above the names is a view of the Chicago skyline, a Chicago Police badge, and a fraternal order of police logo. In an effort to protect the memorial, it has been tucked away on the side of the building where it is surrounded by a wrought iron fence.

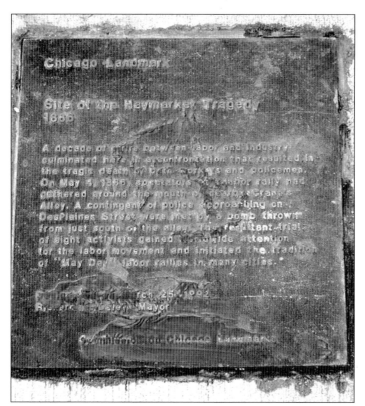

On May 4, 1886, protesters gathered at the old Haymarket Square, now 600 W. Randolph Street, to speak against police actions between strikers and replacement workers at the McCormick Harvester Plant. Without warning, someone threw a bomb and a riot ensued. When the smoke cleared, eight policeman and two civilians were dead. Within weeks, eight anarchists were convicted of murder in what many consider to be one of the most unjust trials in history. This well-worn sidewalk marker on the east side of Des Plaines Street just north of Randolph Street recalls the incident.

The Haymarket Riot Monument stands in the courtyard of the Chicago Police Academy at 1300 W. Jackson Boulevard. This statue, which is a memorial to the policemen who lost their lives in the Haymarket Riot, was unveiled in 1889. Although it originally stood in the old Haymarket Square on Randolph Street, the statue was relocated several times as a security precaution, until it was moved to its present location in 1976. The statue is the work of sculptor John Gelert (1852–1923).

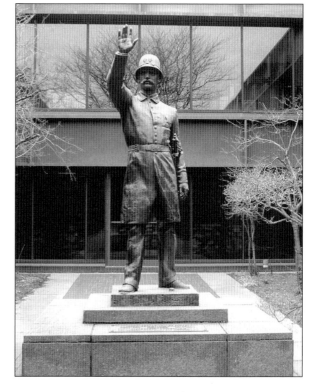

St. Patrick's Roman Catholic Church at 140 S. Des Plaines Street was built in 1852. It is the oldest church and public building in Chicago and one of a handful of structures that survived the Great Chicago Fire of 1871. The base of the church is made of Joliet limestone, while the remainder of the structure is covered in Cream City brick. Pictured here, next to the Celtic cross on the southeast corner of the building, is this bronze tablet that honors the church as a landmark on the National Register of Historic Places.

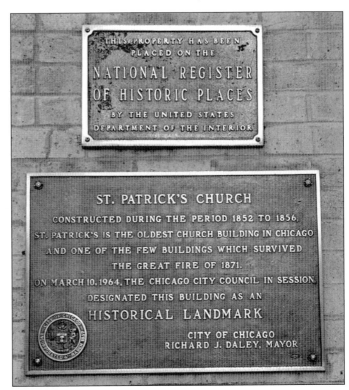

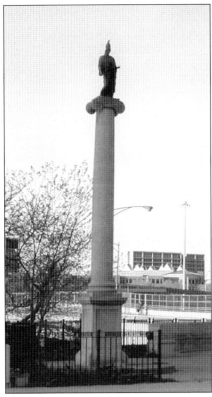

Depicted here is a monument on the southeast corner of Van Buren and Halsted that is a tribute to Chicago's Greek Town. Erected in 1996 by the United Hellenic American Congress, it is also a reminder that the city has one of the largest Greek populations in the United States. Greek Town is situated on a small stretch of Halsted Street between Van Buren and Adams. As visitors walk past the shops and restaurants in Greek Town they often hear the cry of "Opaa!" as waiters serve up the flaming cheese appetizer known as saganaki.

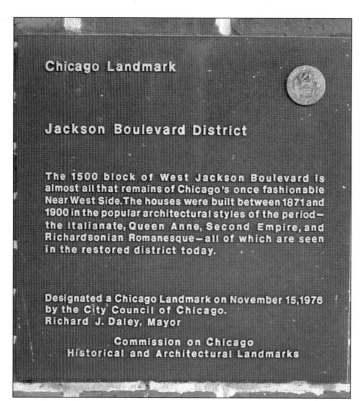

Chicago Landmark

Jackson Boulevard District

The 1500 block of West Jackson Boulevard is almost all that remains of Chicago's once fashionable Near West Side. The houses were built between 1871 and 1900 in the popular architectural styles of the period— the Italianate, Queen Anne, Second Empire, and Richardsonian Romanesque—all of which are seen in the restored district today.

Designated a Chicago Landmark on November 15,1976 by the City Council of Chicago.
Richard J. Daley, Mayor

Commission on Chicago
Historical and Architectural Landmarks

The Jackson Boulevard Historical District stands as a tribute to the city's once-fashionable Near West Side. Today the district consists of the 1500 blocks of Jackson Boulevard and Adams Street and the 200 block of South Ashland Avenue. Most of the homes were built between 1879 and 1893, and many have been restored to their former glory. It was here where many of Chicago's elite, including Mayor Carter Harrison, lived. The district was designated as a Chicago Landmark on November 16, 1976, when this marker was erected.

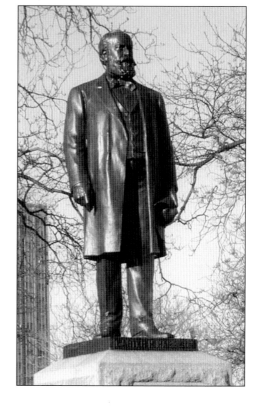

This memorial to Chicago Mayor Carter Harrison (1825–1893) stands in Union Park near Washington Boulevard and Ashland Avenue. Harrison served five terms as mayor and lived just a short distance from where this monument stands. He was one of Chicago's most beloved political figures, but was assassinated on the doorstep of his home by a disgruntled office seeker. This monument, which was unveiled in 1907, is the work of sculptor Frederick Cleveland Hibbard (1881–1955).

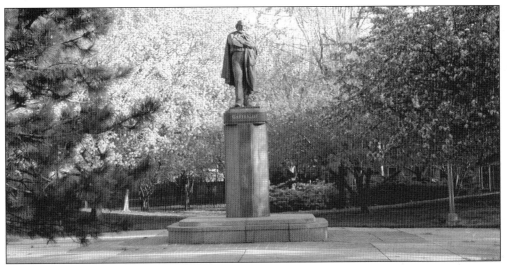

Giuseppi Girabaldi (1807–1882) was an Italian patriot and soldier who is honored with this monument, given to the City of Chicago by a group of Italian Americans known as Legione Girabaldi. The work was created by sculptor Victor Gheraradi, and it was unveiled in 1901. While it originally stood in Lincoln Park, in 1979 it was moved to its present location in Girabaldi Park at 1520 West Polk Street.

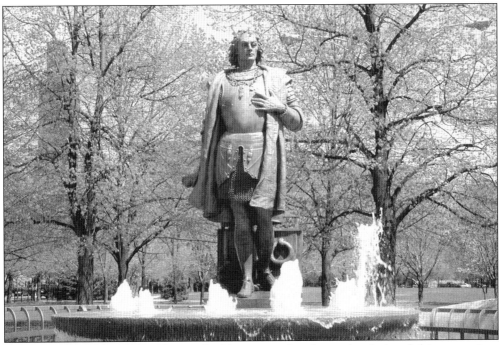

Sir Moses Ezekiel (1844–1917) was a highly respected sculptor who designed this centerpiece for Arrigo Park—a statue of Christopher Columbus that stands in the middle of a granite fountain and weighs over ten tons. The statue was originally exhibited at the 1893 World's Columbian Exposition. It later stood over the entrance to the Columbus Memorial Building at 31 N. State Street. The statue was relocated to the park and unveiled in a dedication ceremony on October 12, 1966.

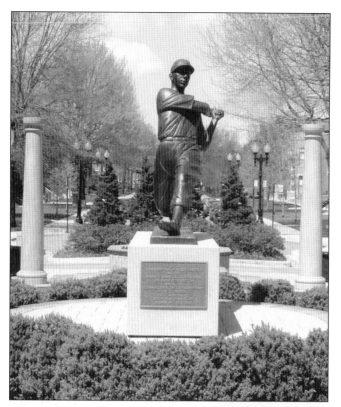

Many Chicagoans often wonder why there is a statue of a New York Yankees baseball player standing in the middle of their city. Well, Joe DiMaggio (1914–1999) wasn't just any baseball player—the "Yankee Clipper" was one of the most popular players of his time and a hero to Italian-Americans. When it was decided that the Italian-American Sports Hall of Fame would be moved from Arlington Heights to Chicago's "Little Italy" neighborhood, the DiMaggio statue was relocated to Taylor Street as well. DiMaggio appeared in person at the at the unveiling on September 26, 1998. The statue was a gift of Anheuser-Busch and the Edward J. DeBartlo Corporations.

Hippocrates (460–377 B.C.), the "father of medicine," is the subject of this 10 foot marble memorial by Athenian sculptor Kostos Georgakas. Appropriately, this work is located on the grounds of the University of Illinois Medical Center at the northeast corner of Taylor and Wood Streets. The statue was the gift of Andrew Fasseas in 1972, but it wasn't until 1980 that it was installed at its present location. This was also the first statue in the Chicago area that honored someone from the Greek community.

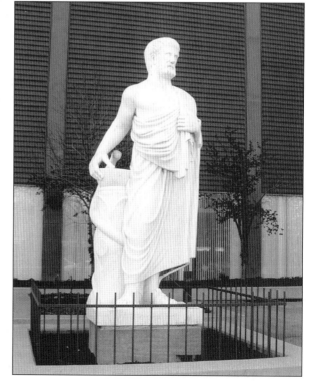

Located in front of Cook County Hospital at 1700 West Harrison Street stands a 28 foot memorial to Louis Pasteur (1822–1895). The monument was placed near the lakefront in 1928, but it was moved to its present location about 20 years later. The monument, consisting of a bronze bust supported by a marble shaft, was created by architect Edward H. Bennett and sculptor Leon Hermant (1866–1936). A draped woman and two children on the west side of the shaft are said to represent humanity, which benefited from Pasteur's work on an inoculation for rabies.

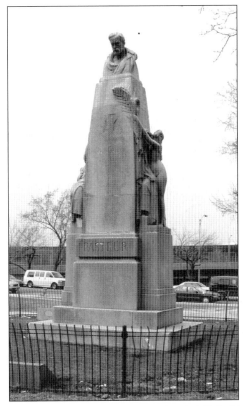

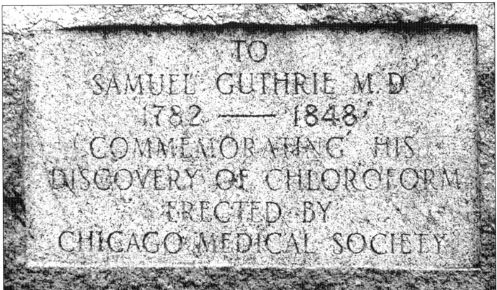

This memorial boulder stands in a small park in front of Cook County Hospital, 1835 W. Harrison Street. It honors Samuel Guthrie (1782–1848), a physician who settled in Sackets Harbor, New York, after serving as a surgeon in the War of 1812. In 1831, he made medical history by discovering chloroform, which was used to anesthetize patients. This monument was erected by the Chicago Medical Society, and it is located near the Louis Pasteur memorial.

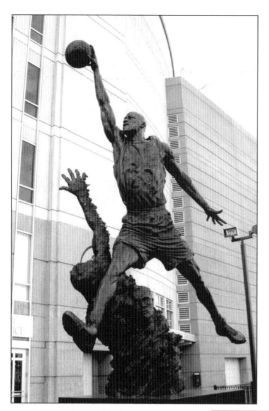

Located in front of the east entrance to the United Center, the Michael Jordan statue is one of the city's most recognizable landmarks. The statue, entitled *The Spirit*, is the work of the husband-wife team of Omri Amrany (b. 1954) and Julie Rotblatt-Amrany (b. 1958). The 12-foot-tall bronze of Jordan weighs 2000 pounds and sits on a five-foot-high black granite pedestal. It was unveiled on November 1, 1994. The inscription on the base reads: "The best there ever was. The best there will ever be." Michael Jordan (b. 1963) is one of Chicago's most beloved heroes and is considered by many to be one of the greatest athletes in the history of team sports.

The Chicago Blackhawks' 75th Anniversary Commemorative Sculpture is the work of local sculptor Erik Blome. The monument features six hockey players who are each wearing uniforms from different eras in Hawks history. The six figures represent the team rather than individual players. The name of every player that has been on the Hawks team since 1926 is sandblasted on the back of the monument. The statue is located at 1800 W. Madison, across the street from the United Center, on the site of the old Chicago Stadium. It was unveiled on October 12, 2000.

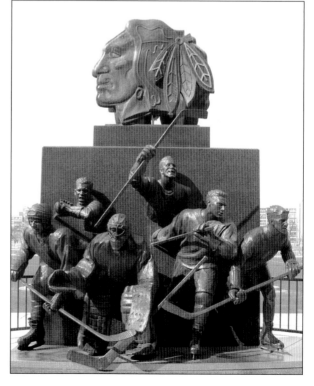

This oversized bronze bust of Reverend Robert Johnson is the work of local sculptor Erik Blome, and it can be found in the headquarters of Inner Voice at 1600 W. Lake Street. Johnson founded Inner Voice which is a learning center supported by the City of Chicago. It not only helps the homeless, but it gives former drug addicts a place to recover and find a new way of living. Johnson single-handedly opened the learning center and several soup kitchens on the West Side. While he is not well known to many in people in Chicago, he is recognized as a hero to West Side residents and city administrators.

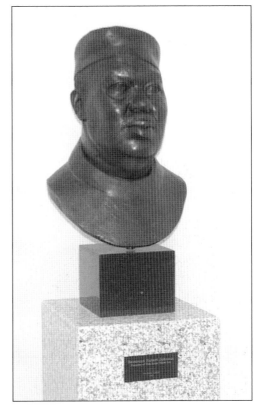

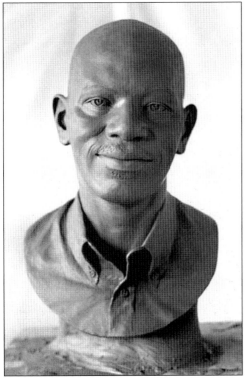

In 1993, the father of Chicago basketball legend Michael Jordan was tragically killed. To honor the memory of James R. Jordan (1936–1993), the Chicago Bulls and Michael Jordan donated funds for the creation of a center to serve the residents of Chicago. In 1996, the James Jordan Boys and Girls Club and Family Life Center at 2102 W. Monroe opened its doors. This bust of the elder Jordan by local sculptor Erik Blome can be found in the lobby of the center. Two reliefs of James R. Jordan (which are also the work of Blome) can be found on the outside of the center.

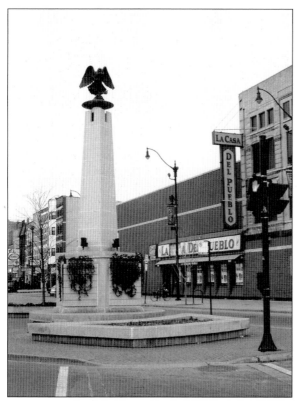

Pictured here is an obelisk topped by a golden eagle that can be found at Loomis and 18th Street. It stands in the middle of a small plaza that is located in the heart of the Pilsen neighborhood. Designed by Alphonse Guajardo and Associates, the plaza reflects the architecture of Mexico, and the eagle was presented by a former mayor of Mexico City. It is believed that Mexico City was built by Aztec Indians on a site where an eagle was seen perched upon a cactus while devouring a snake.

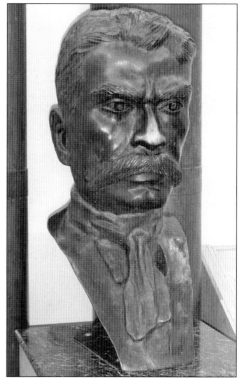

This bronze bust of Mexican revolutionary Emiliano Zapata (1879–1919) is located in the lobby of the Harrison Park Fieldhouse at 1824 S. Wood. Zapata was the leader of the Mexican agrarian movement and one of the most prominent figures in Mexico between 1910 and 1919. He was killed by his enemies in 1919, but to this day he is one of the most celebrated heroes in Mexican history. His grave is considered a sacred place by the Indians of Mexico.

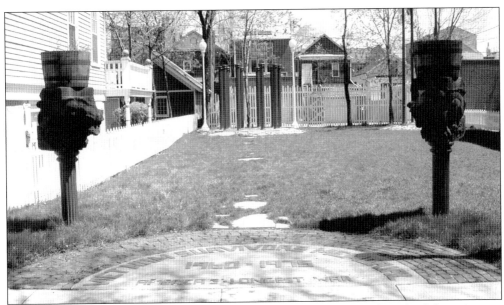

The Vietnam Survivors' Memorial is located at 815 S. Oakley. It is built on land that was once a vacant lot. The entrance to the memorial is guarded by two gargoyles. The inscription at the entrance reads "Vietnam Survivors Park 1960–1975 America's Longest War." A stone walkway leads to the set of red pillars in the rear of the park. The memorial is the creation of West Side resident and Vietnam veteran William Lavicka.

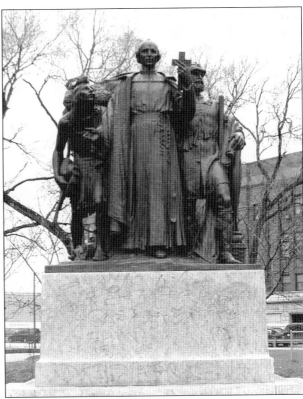

Designed by sculptor Hermon Atkins MacNeil (1866–1947) with assistance from architects Holabird and Roche, this magnificent monument to missionary Jacques Marquette (1637–1675) was erected in 1926. The statue depicts Marquette with Louis Jolliet (1645–1700) and an Indian guide as they came down the South Branch of the Chicago River in 1673. The sculpture was commissioned by the B.F. Ferguson Monument Fund and is located in front of Harrison High School at 24th Street and Marshall Boulevard.

One Family One World is the work of little-known sculptor Sidney Murphy. As the winner of a local high school student design competition, Murphy was given permission to have his sculpture displayed on the median of Douglas Boulevard and Kedzie Avenue. Unfortunately, this little artistic gem that was unveiled in 1972 is made of a masonry-like substance that has deteriorated badly in the harsh Chicago climate.

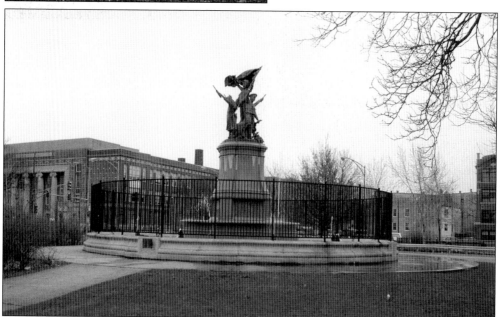

The American Youth and Independence Day Fountain Sculpture is the work of sculptor Charles J. Mulligan (1866–1916). This bronze sculpture, which sits atop a 15 foot granite pedestal, features two girls and two boys celebrating the Fourth of July. The statue is surrounded by a large granite pool. This work is located at Douglas and Independence Boulevard and was unveiled on July 4, 1902.

This statue of Robert Burns (1759–1796) is found in Garfield Park. Cast in Edinburgh, Scotland, the work is made of bronze and stands 10 feet high. The sculptor, William Grant Stevenson (1849–1919), tried to capture the spirit of the Scottish national poet by depicting him holding a copy of his own poems. Originally, famous lines from some of Burn's poems were cut into panels on the base of the statue, but they have long since been removed. The work was unveiled in Chicago on August 26, 1906, and this photograph was taken shortly thereafter.

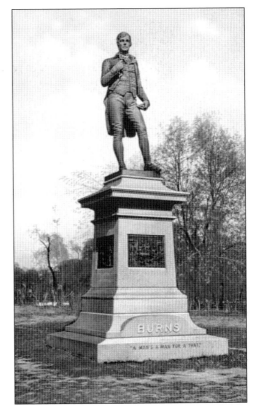

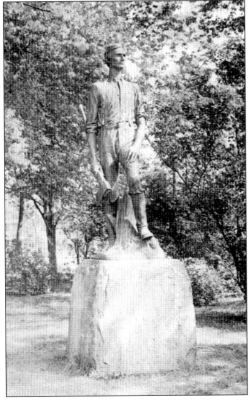

Pictured here is the monument entitled *Lincoln the Railsplitter*, which was designed by sculptor Charles J. Mulligan (1866–1916). It features a young, muscular, and clean shaven Abraham Lincoln holding an ax by his side. The bronze work stands on a small boulder near the Garfield Park Administration Building. The monument was purchased by the West Park Commission and unveiled in 1911. This photograph was taken around 1919. The monument has recently undergone a complete restoration.

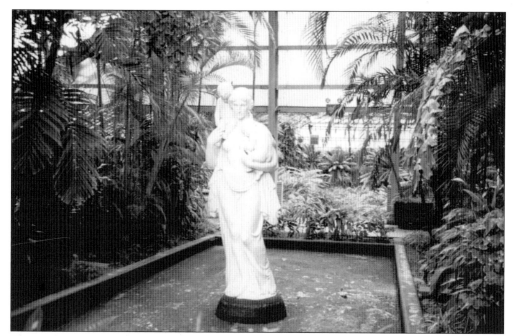

This sculpture, entitled *Charitas*, was completed by sculptor Ida McCelland Stout in 1922. It is located in the Garfield Park Conservatory at 300 N. Central Park Boulevard. Although the sculpture originally stood in front of the Daily News Fresh Air Sanitarium in Lincoln Park, it was removed and placed in storage, where it was all but forgotten. In the mid-1990s, the statue was found. After a complete restoration, it was installed as the centerpiece of the fern room in the conservatory. The statue is sometimes placed in storage when other exhibits are displayed at the Conservatory.

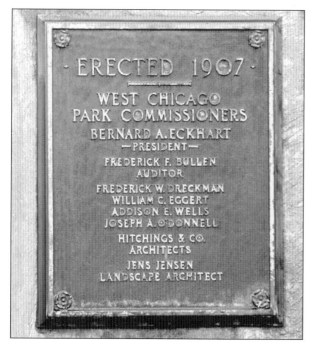

Completed in 1907, the Garfield Park Conservatory at 300 N. Central Park Boulevard is one of Chicago's most beautiful indoor locations. Designed by noted landscape architect Jens Jensen (1860–1951), the Conservatory contains several rooms that feature tropical plants and various water themes. At the center of the Conservatory is the Fern Room, which Jensen designed to reflect what the city's natural landscape might have appeared like a million years ago. This bronze marker found in the Fern Room honors Jensen and other members of the West Park Commission who were responsible for the creation of the Conservatory.

Sitting in front of the entrance to the Fern Room in the Garfield Park Conservatory is this marble work, entitled *Idyl*, by sculptor Lorado Taft (1860–1936). It is considered by many to be one of the artist's most popular sculptures, and it is a favorite with many visitors. The work features two figures thought to be a shepherd and a nymph gently embracing each other. Taft's works can be found throughout the city, and he remains one of Chicago's most beloved sculptors.

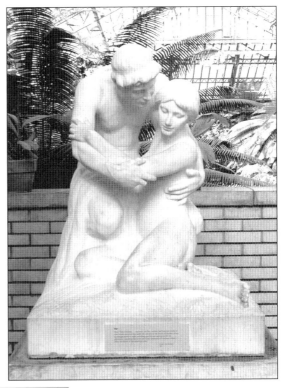

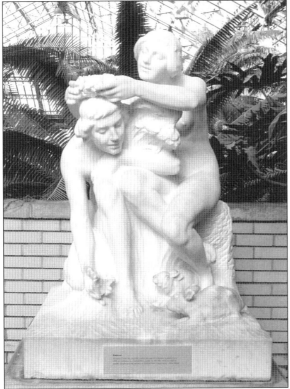

This elegant marble sculpture was also completed by artist Lorado Taft. The work, entitled *Pastoral*, depicts two young girls—one is placing a wreath upon the other's head as she feeds some rabbits. This sculpture also stands in front of the entrance to the Fern Room. Both this work and the *Idyl* were crafted in plaster for a 1909 art exhibit at Garfield Park. In 1913, both works were redone in marble. The conservatory provides a lush green tropical backdrop for these classically inspired works of art.

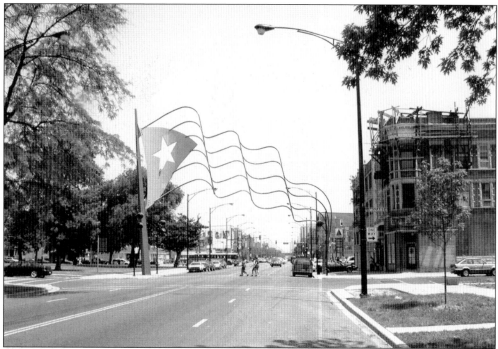

Pictured here is one of the two steel-sculptured Puerto Rican flags that mark the entrance to *Paseo Boricua*. At the suggestion of community leaders and city officials, the flags were raised to stimulate economic development in the area. Each flag is nearly 60 feet high and 60 feet wide, and each sculpture weighs 45 tons. *Paseo Boricua* stretches for nearly a mile along Division Street and is the heart and soul of the Humboldt Park community. The sculptures, which are the largest Puerto Rican flags in the world, have become a symbol of pride in the community.

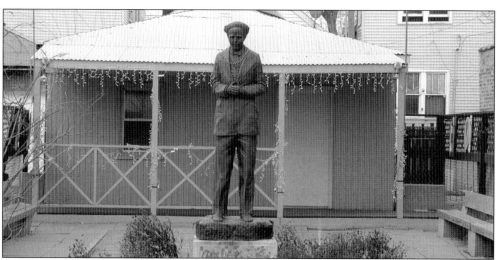

This bronze statue of Pedro Albizu-Campos (1891–1964) stands in a garden at 2625 W. Division Street. Albizu-Campos was a fierce advocate of Puerto Rican independence who led an uprising against the United States government in Puerto Rico in 1950. Later he was implicated in the failed attempt to assassinate President Harry Truman. It was originally intended to be placed in Humboldt Park, but after opposition from City Council, the plan was rejected.

Pictured here is a work entitled *The Miner's Homecoming* that is the creation of sculptor Charles J. Mulligan (1866–1916). This limestone sculpture features a muscular miner, who is wearing his lantern cap as he kneels down to hug his young child. This is one of several statues of miners by Mulligan, but the only one in Chicago. In 1911, it was placed in Humboldt Park near Division Street and California Avenue, where it still stands today. Unfortunately, this beautiful limestone sculpture has not held up well in the harsh Chicago climate.

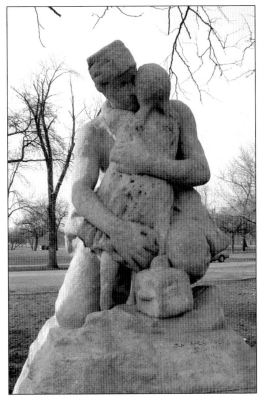

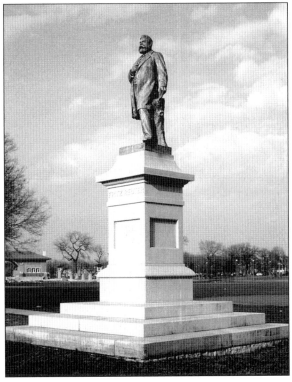

This 9-foot-tall bronze monument to Fritz Reuter (1810–1874), which stands on a granite pedestal, is the work of sculptor Franz Engelsman. Reuter was a German writer and a hero to his people. His political beliefs led to his imprisonment in 1833, and he remained jailed until he was given amnesty in 1840. 60,000 people attended the unveiling of his statue in Humboldt Park in 1893, while a German band and choir with 300 members performed. The statue can still be found in the park on Humboldt Boulevard near Division Street.

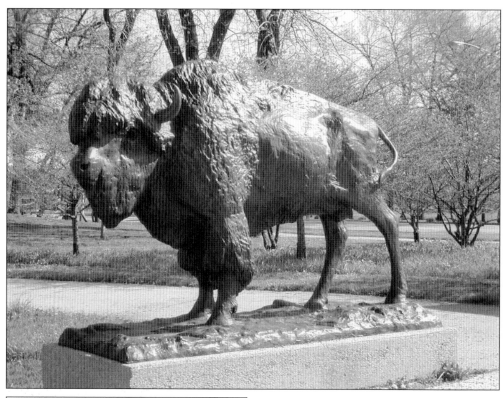

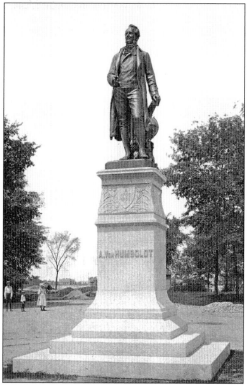

Pictured here is one of two Bison that guard the east entrance to the Humboldt Park Rose Garden. One bison stands with a lowered head, while the other stares straight ahead. They were created from models provided by sculptor Edward Kemeys (1843–1907) for the grounds of the World Columbian Exposition in 1893. The garden provides a colorful background for the bison, which were unveiled in the park in 1911. Kemeys is best known for his Lions which stand at the entrance of the Art Institute.

This 10 foot bronze monument of German naturalist and explorer Alexander von Humboldt (1769–1859) is the work of sculptor Felix Gorling. It features Humboldt standing with a globe at his feet, which symbolizes his travels throughout the world. The statue was cast in Europe and donated by prominent Chicago brewer Francis J. Dewes (1845–1921). The work was unveiled in 1892 and stands in Humboldt Park near the Boat House. This photograph was taken in 1893.

Leif Ericson is the Norse discoverer of America. In 999 he was commissioned by King Olaf of Norway to sail to Greenland and help spread Christianity. On the return voyage, he was blown off course and discovered America. In honor of the discovery, Chicago's Norwegian community unveiled this nine-foot-tall bronze statue of Ericson in Humboldt Park on October 12, 1901. It is the work of sculptor Sigvald Asbjornsen (1867–1930). This work can be found on Humboldt Boulevard between Division Street and North Avenue.

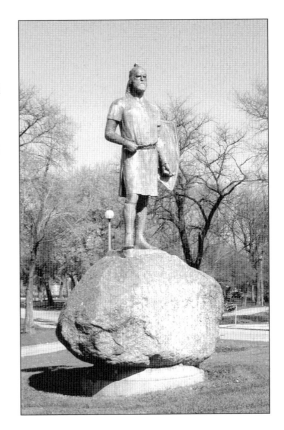

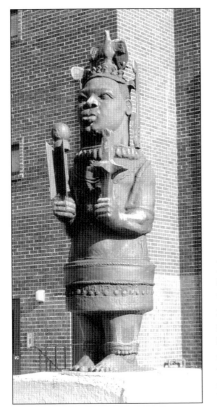

Entitled *Our King*, this work by African-American sculptor Geraldine McCullough (b. 1922) pays tribute to Dr. Martin Luther King, Jr. (1929–1968). This nine-foot-tall bronze monument features Dr. King as an African chieftain. He is wearing a tiger-tooth necklace and the centerpiece of his crown is the dove of peace. He is depicted here holding an Indian prayer wheel in his right hand and a Coptic cross in his left one. The memorial stands in front of the Martin Luther King Apartments at Madison and Kedzie.

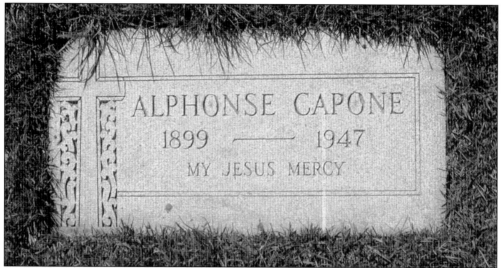

This plain stone at Mount Carmel Cemetery marks the grave of Chicago's most famous gangster, Al Capone (1899–1947), who came from New York City to Chicago in 1920 during the era of prohibition. As "Scarface," Capone took control of the city's enormous illegal liquor trade, he eliminated any opponents who dared to compete against him. Through bootlegging, gambling, prostitution, and other illegal activities, he took in $105 million in 1927 alone, according to government sources. In 1931, Capone was sentenced to an 11-year prison term that effectively ended his rule in Chicago.

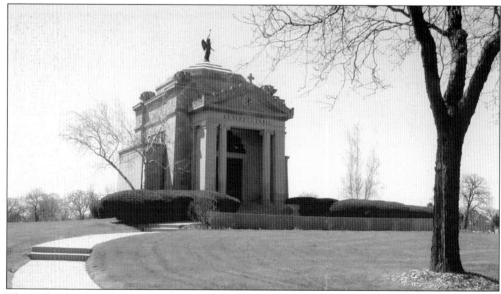

The Bishop's Mausoleum at Mt. Carmel Cemetery holds the bodies of some of Chicago's most famous Catholic leaders including Cardinal Samuel Stritch, Cardinal John Cody, and Cardinal Joseph Bernardin. The massive Bedford limestone structure sits on top of a hill in the center of the cemetery. Behind the double bronze doors, which are flanked by two Corinthian columns, is a small chapel decorated with Italian marble and Venetian mosaics. Above the altar is the risen Christ and a scene of the Last Supper. Construction on the mausoleum started in 1905 and was completed in 1912.

On December 1, 1958, a fire broke out at Our Lady of the Angels Catholic Elementary School located at 3820 W. Iowa. By the time the fire was extinguished, 92 children and 3 nuns were dead. Scores more suffered serious burns and injuries. The exact cause of the fire was never determined. This memorial at Queen of Heaven Cemetery is inscribed with the names of all the victims, and the bodies of 25 of the children killed in the fire are buried near this memorial.

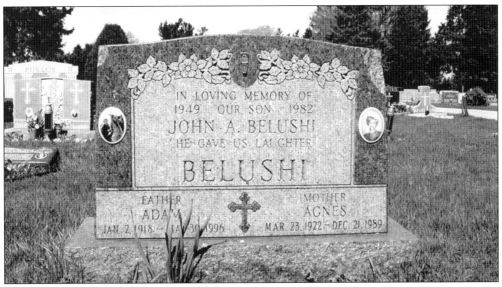

John Belushi (1949–1982) was one of Chicago's most popular and critically acclaimed comedic actors. In 1970, he became a member of Chicago's Second City, the legendary Old Town comedy improvisation group, before joining the cast of NBC television's *Saturday Night Live* in 1975. In 1978, he made his big screen debut in the wildly successful comedy, *National Lampoon's Animal House*. He made other successful films, released hit albums, and toured the country with his band the Blues Brothers. Unfortunately, he also lived a life of excess that led to his death as a result of a drug overdose. This cenotaph at Elmwood Cemetery in River Grove is a memorial to Belushi.

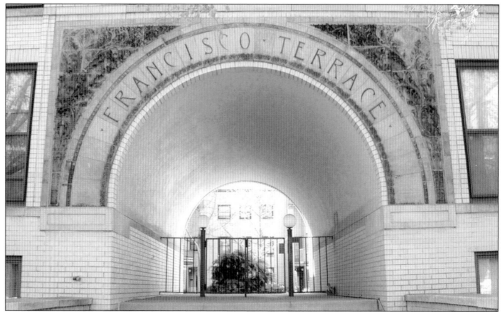

The Francisco Terrace Apartments were designed in 1895 by architect Frank Lloyd Wright (1867–1959). The apartments which stood at 235–237 N. Francisco were designed for one of Wright's most important early clients, Edward Carson Waller. In 1973, as the apartments were about to be demolished, this terracotta arch and other decorative elements were salvaged. The half-circle entry arch was refurbished and reassembled and now stands here in front of the Euclid Place townhouses on Lake Avenue in Oak Park. An excellent surviving example of one of Wright's early works, the arch has a Louis Sullivan-like appearance. (Sullivan was Wright's mentor.)

Resurrection Cemetery at 7200 S. Archer Road contains numerous monuments, markers, and memorials. The most famous of these is "Resurrection Mary" but whether or not she really exists has been the subject of debate for years. Legend says that Mary was a beautiful young blonde who was killed in a car crash in 1931. Since then, sightings of Mary along Archer Avenue have been reported on numerous occasions. If you look closely at this picture of the main entrance to the cemetery, you can see what appears to be the figure of a young girl fitting Mary's description seemingly passing through the locked gates.

Three

DOWNTOWN

The Downtown area contains some of the city's most recognizable monuments including Buckingham Fountain, the Picasso in the Daley Center Plaza, and the Lions that guard the entrance to the Art Institute of Chicago. It should come as no surprise that here, in the oldest area of Chicago, there are several monuments, markers, and memorials that honor early settlers and events in the history of the city. On the Michigan Avenue Bridge, there are pylons that honor pioneers Marquette, Jolliet, LaSalle, and the "Father of Chicago," John Kinzie. The pylons also that commemorate Fort Dearborn and the rebirth of Chicago after the Great Fire of 1871. Also on the Michigan Avenue Bridge is a plaque that recalls the reversal of the river which was completed in 1900, and this certainly has to be ranked as one of the greatest engineering feats since the creation of the pyramids in ancient Egypt.

The greatest concentration of monuments in the downtown area can be found in Grant Park. Here there are works that honor General John Logan, Theodore Thomas (founder and conductor of the Chicago Symphony Orchestra), union leader James C. Petrillo, President Abraham Lincoln, and Christopher Columbus, explorer and discoverer of America. Other works in the park include the Bloch Cancer Survivors Memorial, the arch which was removed from the old Stock Exchange Building, the Fountain of the Great Lakes, the Rosenberg Fountain, and two equestrian works entitled the *Bowman* and the *Spearman* which mark the entrance to Grant Park.

One of the great things about the downtown area is that it is relatively compact and easily navigable. As a result, many of these monuments can be visited on foot, unlike other areas of the city where works are spread out over a wide area necessitating the use of transportation. By walking just a short distance in almost any direction, one can view priceless works of art by some of the world's most famous artists.

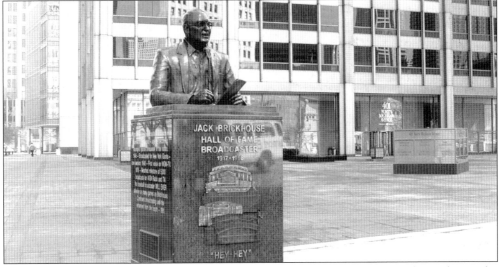

This statue of the Hall of Fame broadcaster Jack Brickhouse (1917–1998) is located near the Equitable Building on Michigan Avenue. When this statue (created by Daprato Rigali Studios, Inc.) was unveiled on September 14, 2000, the ceremony was attended by Jack's widow Pat, Illinois Governor George Ryan, and other dignitaries. There was some controversy when the Tribune Company elected to place the statue in its current spot, rather than at Wrigley Field, where Brickhouse had spent many years announcing Cubs games.

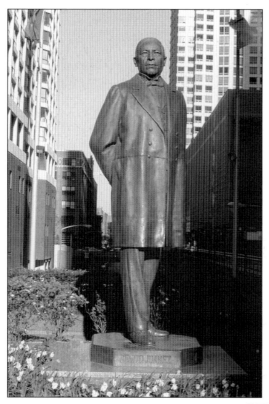

This statue of former Mexican president and hero Benito Juarez (1806–1872) stands in the Plaza of the Americas, 430 N. Michigan Avenue. Heriberto M. Galindo, the counsel general of Mexico in Chicago, presented the statue to the city as a gift from the Mexican government. The 16 foot bronze work weighs five tons and was unveiled in February, 1999. It replaces a smaller statue of Juarez that stood in the plaza. Juarez is considered one of the greatest political figures in the history of Mexico.

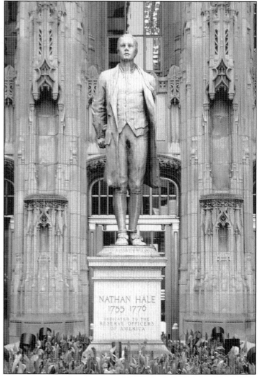

Nathan Hale (1755–1776) was an American soldier and a hero of the American Revolution. He served in the siege of Boston and later volunteered to spy on the British. During the mission, he was discovered; then he was hanged without a trial. He is best remembered for his words: "I only regret that I have but one life to lose for my country." This statue, which stands in the plaza of the Chicago Tribune Tower at 435 N. Michigan, is the work of sculptor Bela Lyon Pratt (1867–1917). It was unveiled on June 4, 1940.

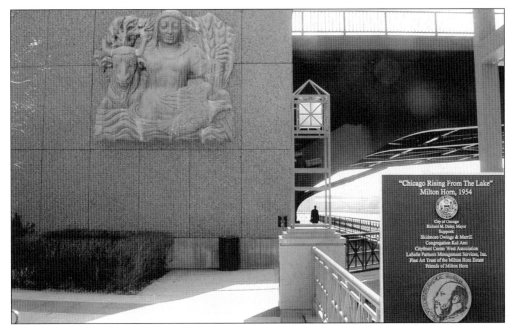

This 3 ton bronze sculpture, entitled *Chicago Rising From the Lake*, is the masterpiece of artist Milton Horn (1906–1995). The sculpture features a woman holding grain in her left hand as she embraces a bull, which is symbolic of Chicago as a leader in commodities. The sculpture was commissioned by the city and unveiled in 1954. It adorned a building on West Wacker Drive until 1983 when the building was razed. The sculpture then lay abandoned in a Southwest Side field for many years until it was finally restored and placed on the Columbus Drive Bridge.

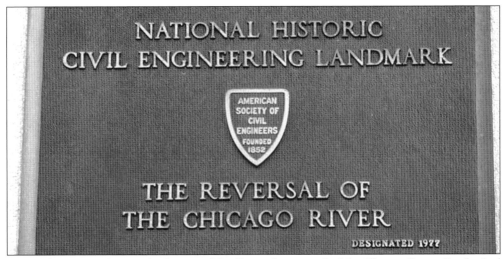

One of the greatest feats in the history of the City is the reversal of the Chicago River. On the 2nd and 3rd of August 1885, 6 inches of rain filled the Chicago River sending sewage into the lake and polluting the water supply. Thousands of people died from cholera, dysentery, and typhoid. As a result, the city embarked on one of the most massive and costly engineering undertakings in Chicago history—the reversal of the river. It took eight years, $40 million, and nearly 9,000 men; but when it was completed, the river flowed away from the lake disposing of sewage—thus protecting the water supply. This plaque on the Michigan Avenue Bridge marks the event.

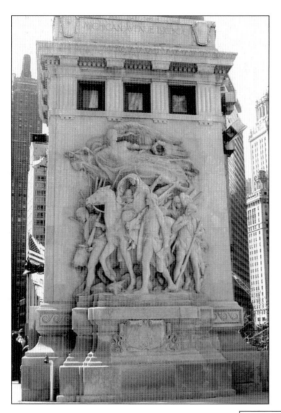

This work on the northwest pylon of the Michigan Avenue Bridge is entitled *Pioneers* and is the work of renown sculptor James Earle Fraser (1876–1953). Early Chicago pioneer and fur trader John Kinzie (1763–1828) is the focus of this limestone sculpture. Kinzie lived with his family in a log cabin near where the Michigan Avenue Bridge, stands today. He was the city's first permanent white settler and is often referred to as the "Father of Chicago."

Another work by sculptor James Earle Fraser can be seen on the northeast pylon of the Michigan Avenue Bridge. This one is entitled *Discoverers* and features explorers Jacques Marquette (1637–1675) and Louis Jolliet (1645–1700). In 1672, during their journey of discovery, Marquette and Jolliet spent eight days along the banks of the Chicago River, where the Michigan Avenue Bridge now stands. The statue also features discoverers Rene Robert Cavelier, Sieur de LaSalle, and Henri de Tonti.

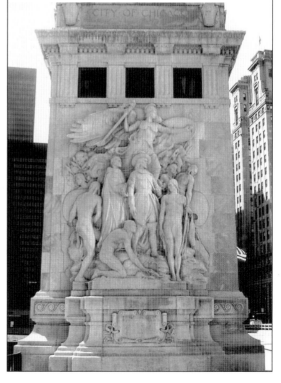

The southwest pylon of the Michigan Avenue Bridge features a work entitled *Defense*, by sculptor Henry Hering (1874–1949). The sculpture depicts Captain William Wells defending early settlers against the Indians during the Fort Dearborn Massacre on August 15, 1812. The attack took place a few miles south of the Michigan Avenue Bridge, although Fort Dearborn stood close to the southwest pylon. This work was commissioned by the B.F. Ferguson Monument Fund.

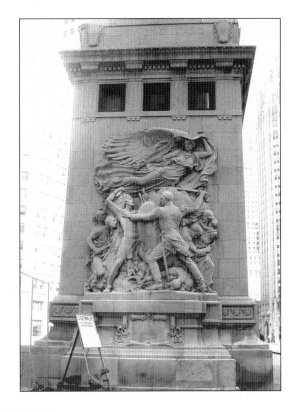

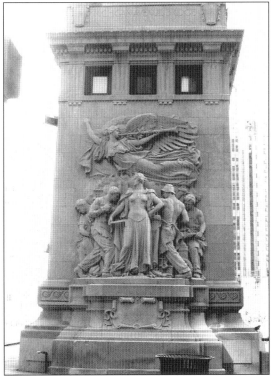

The southeast pylon features another work by sculptor Henry Hering. This one, entitled *Regeneration*, honors Chicago's rise from the ashes after the Great Chicago Fire in 1871. The work features a steadfast and strong woman holding a carpenter's square. Her crown is inscribed with Chicago's unofficial "I Will" slogan and she is surrounded by workers who are rebuilding the city. Hering was famous for his work with classical figures, and some of his other work can be found in Chicago at the Field Museum and at Union Station.

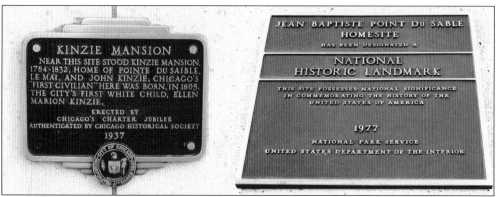

Pioneer Court, which stands on the east side of Michigan Avenue near the Tribune Building, is the site of these two markers that honor early Chicago pioneers. The first is the Kinzie Mansion marker which reads, "Near this site stood Kinzie Mansion, 1784–1832, home of Pointe du Sable, Le Mai, and John Kinzie, Chicago's first civilian." The second work, which honors Point du Sable reads, "Jean Baptiste Point du Sable homesite has been designated a National Historic Landmark."

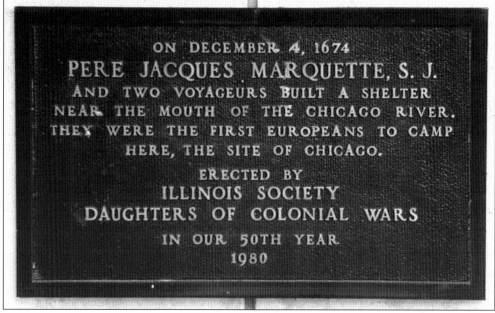

Another monument at Pioneer Court honors Father Pere Jacques Marquette (1637–1675). It reads, "On December 4, 1674, Pere Jacques Marquette S.J. and two voyagers built a shelter near the mouth of the Chicago River. They were the first Europeans to camp here, the site of Chicago." Later Marquette and his companions (who became the first Europeans on record to live in Chicago) settled in a cabin near what today is Damen Avenue and the South Branch of the Chicago River.

The first true settlement in Chicago was a log structure built in 1803, known as Fort Dearborn. Named in honor of U.S. Secretary of War Henry Dearborn, the fort served as a military post for the U.S. government. The original fort was destroyed by Indians in 1812 and rebuilt on the same location in 1816. The second Fort Dearborn was demolished in 1856. The site was designated as a landmark, and a historical marker commemorating it was erected on the 360 N. Michigan building where part of the fort stood.

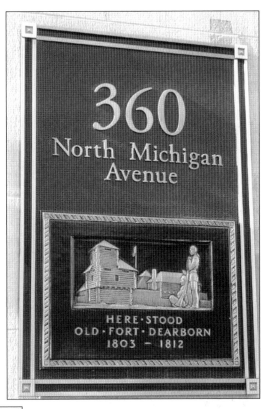

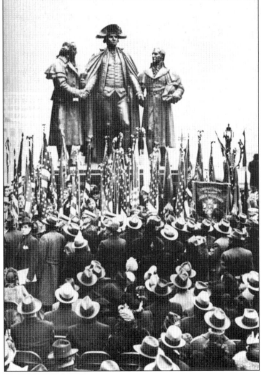

The Heald Square Monument honors American Revolutionary heroes Robert Morris (1734–1806), Haym Salomon (1740–1785), and George Washington (1732–1799). The large bronze sculpture features the three patriots standing with hands linked together in a display of unity. The monument is the work of several sculptors, most notably Lorado Taft (1860–1936) and Leonard Crunelle (1872–1944). The statue was unveiled on December 19, 1941, but was designated as a Chicago landmark nearly 30 years later, on September 15, 1971. The statue derives its name from its location in the center of Nathan Heald Square. This photograph was taken at the unveiling.

Ludwig Mies van der Rohe (1886–1969) is considered by many to be one of the founding fathers of modern architecture. His belief that "less is more" is reflected in his bare-bones international style of architecture. Although famous throughout the world, Mies chose to live in Chicago. He served as the director of architecture at the Illinois Institute of Architecture and many of his most famous buildings are located in Chicago. The last building he designed was the IBM building—so it is fitting that this bust of Mies stands in the lobby at One IBM Plaza. It is the work of sculptor Marino Marini (1901–1980).

This 25-foot-tall, V-shaped steel sculpture, entitled *Crossings*, is the work of German artist Hubertus von der Goltz. It features a man attempting to balance himself on top of the monument. The figure symbolizes the citizen who will, according to the artist, "contribute to the balancing and blending of the City of Chicago on the brink of the 21st Century." The sculpture is located in the LaSalle Gateway Plaza in front of the old Traffic Court building at 321 N. LaSalle Street. It was unveiled on May 22, 1998, in a ceremony attended by Mayor Richard M. Daley.

The Merchandise Mart Hall of Fame is located in front of the building's main entrance on the Chicago River between Orleans and Wells. The Hall of Fame features eight bronze busts of leading American merchandisers: Marshall Field (1835–1906), Edward Filene (1860–1937), George Huntington Hartford (1830–1917), Julius Rosenwald (1862–1932), John Wanamaker (1838–1922), Aaron Montgomery Ward (1843–1913), General Robert Wood (1843–1913), and Frank Winfield Woolworth (1852–1919). The busts, which were designed by various sculptors, were unveiled on June 30, 1953.

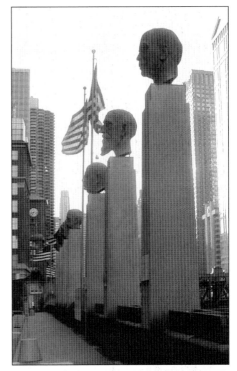

On April 13, 1992, employees of the Midwest Dredge & Dock Company inadvertently punctured a hole in one of the city's underground freight tunnels as they were driving a new piling into the Chicago River bottom. Millions of gallons of water rushed into the vast network of abandoned tunnels. No one was killed or seriously injured, although nearly every basement in the Loop was flooded. Even though the city responded quickly and the tunnels were drained, the cost to businesses and the city was staggering. This is the site near the Kinzie Street Bridge where the "Great Chicago Flood" originated.

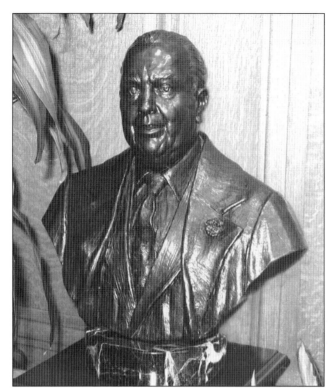

Mayor Richard J. Daley (1902–1976) was undeniably one of Chicago's most beloved and respected civic leaders. As mayor from 1955 until 1976, Daley created a multiethnic coalition that helped Chicago to become "the city that works." His massive public works and urban renewal programs helped to make Chicago one of the greatest cities in the world. Remarkably, there is no statue of Mayor Daley in Chicago. There is, however, a bust of the Mayor in the Harold Washington Library Special Collections Room, and the bronze bust pictured here, which is in the City Hall office of Mayor Richard M. Daley.

A bronze relief, known as *The Iroquois Memorial Tablet*, by sculptor Lorado Taft (1860–1936) is located above the exit door in the northwest lobby of City Hall. The tablet was originally displayed in the Iroquois Memorial Hospital which was erected in memory of those who died in the Iroquois Theatre Fire in 1903. The work features an angel overlooking a group of people and a woman holding the body of a child. When the hospital was demolished in 1951, the tablet was lost, but it was rediscovered by a janitor in the basement of City Hall. No one is certain how this work found its way into the basement.

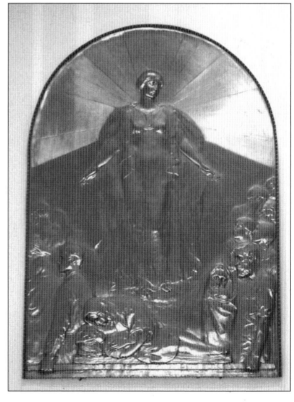

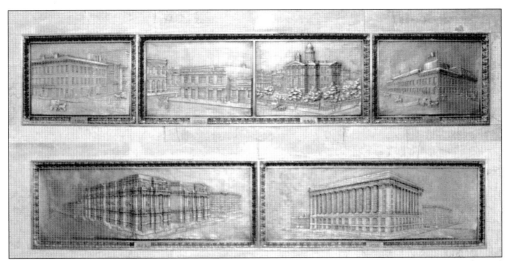

These two bronze plaques (which can be found in the lobby of City Hall at 121 N. LaSalle) depict the six buildings that have served as Chicago's City Hall. The first two buildings were used in 1837 and 1848. The third City Hall (designed by architect John M. Van Osdel in 1853) was erected on the site of the present City Hall. It was destroyed by the Chicago Fire in 1871. In 1872, a temporary City Hall was built around an old water tank, where the Rookery now stands on the southeast corner of LaSalle and Adams. The fifth building, designed by architect James Egan, was completed in 1885 and stood on the site of present day City Hall for 20 years. The present City Hall was completed in 1911, and is the work of Holabird & Roche.

Daniel Pope Cook (1794–1827) is honored with this monument, which can be found on the first floor of the County Building at 118 N. Clark Street. He was one of the youngest and most successful statesmen in Illinois history. While he only lived until age 33, he became a lawyer, newspaper publisher, judge, attorney general and United States Congressman. Cook County, which was established on January 15, 1831, was named in his honor.

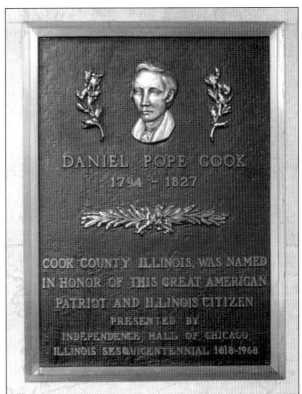

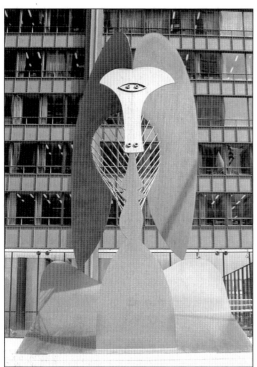

The Picasso sculpture that stands in the Richard J. Daley Center Plaza has become one of the city's most recognizable works. It is one of those sculptures that every Chicagoan seems to have an opinion about—some love it and some hate it. Either way, the work is something that evokes emotion from almost all who view it. The 162 ton sculpture is the work of Pablo Picasso (1881–1973). Art critics have suggested that the sculpture is a portrait of a woman, a bird, a lion, or perhaps a portrait of Picasso's Afghan dog. As a result of this creation, Picasso has become forever linked with Chicago— a city he never set foot in.

This granite memorial holds a bronze circular disk in which a natural gas flame burns perpetually. Surrounded by a wrought iron fence, the eternal flame stands on the eastern portion of the Daley Plaza. The memorial was created by the City of Chicago at the request of veterans' organizations, and it was dedicated to the "men and women who have served in our armed forces." The eternal flame was lit on August 22, 1972, at a dedication ceremony led by Mayor Richard J. Daley.

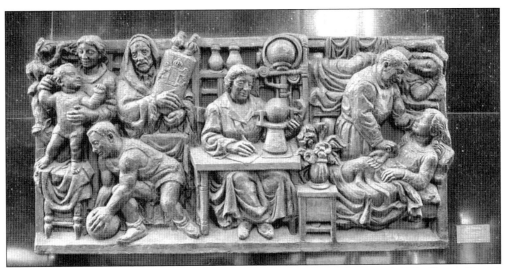

The creation of artist Milton Horn (1906–1995), this bronze work is entitled *The Spirit of Jewish Philanthropy*. It is located on the exterior of the Jewish Federation of Metropolitan Chicago building on the southeast corner of Franklin and Madison. The work depicts the spirit of care and the various services offered by the Jewish Federation. Several of Horn's other works can be found throughout the city.

Most major cities like Chicago have established an official city datum, which is a standard elevation tied to some known point. The datum is then used by architects and engineers on blueprints for major construction projects to establish a ground zero. While the datum is intended to avoid confusion, there can still be problems. In 1989, the city and the state decided to dig a pedestrian tunnel between City Hall and the State of Illinois Building. The city started on one end and the state started on the other, but when they met in the middle they were nine inches off. It turns out one of the blueprints wa not using the Chicago datum. The city's official datum marker can be found on the exterior of the Northern Trust Building at 50 S. LaSalle Street.

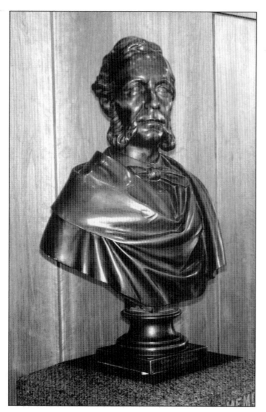

This bust in the Federal Post Office at 211 S. Clark Street honors George Buchanan Armstrong (1822–1871). He is considered the founder of railway mail service in the United States. As an assistant postmaster in Chicago, Armstrong conceived the idea of sorting mail on trains. His first "traveling post office" was put into service between Chicago and Iowa in August of 1864. His concept soon became the standard method of mail delivery between most states. The bust is the work of Leonard Wells Volk (1828–1895). (Both Armstrong and Volk are buried in Rosehill Cemetery.)

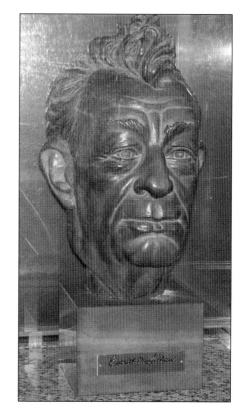

This bust of Everett McKinley Dirksen (1896–1969) can be found in the lobby of the Federal Building, which also bears his name, at 219 S. Dearborn Street. Dirksen was a highly respected U.S. Representative and Senator who helped secure passage of the Nuclear Test-Ban Treaty of 1963 and the Civil Rights Act of 1964. The bust, which is covered by a clear protective plastic case, is the creation of sculptor Eric Olsen.

Standing over the entrance to the Chicago Bar Association Building at 321 S. Plymouth Court is this statue of Themis, the Greek Goddess of Justice and Law. The statue symbolizes fair and equal administration of the law without corruption, avarice, prejudice, or favor. This cast-aluminum figure, which was erected in 1990, is the work of artist Mary Block. The Chicago Bar Association, founded in 1874, is one of the oldest and most active bar associations in the United States.

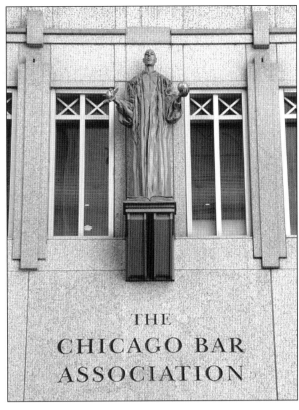

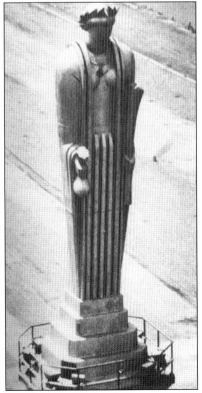

Sitting high atop the Board of Trade Building, at 141 W. Jackson, is a 30-foot-high and 6,500 pound cast aluminum statue of Ceres, the Roman goddess of grain. In her right hand, Ceres holds a bag of corn, and in her left a sheaf of wheat. The statue, which was placed on top of the 45-story building in 1930, had deteriorated as a result of prolonged exposure to the elements until it was removed and fully refurbished in 1988. This work by sculptor John Storrs (1885–1956) is hard to fully appreciate because it is 300 feet above street level. The statue was commissioned by architects Holabird and Root, who also designed the building.

In front of the western entrance to One Financial Plaza, 440 S. La Salle Street, stands this magnificent equestrian statue. This monument, entitled *San Marco II*, is the work of Venetian artist Ludovico de Luigi (b. 1933). De Luigi modeled the work after the horses that used to stand in Venice's San Marco Square. For centuries, the horses greeted visitors to Venice, but, as a result of deterioration, they had to be placed permanently in storage. Saddened over the horses' removal, De Luigi was inspired to create this work, which was unveiled in November 1986.

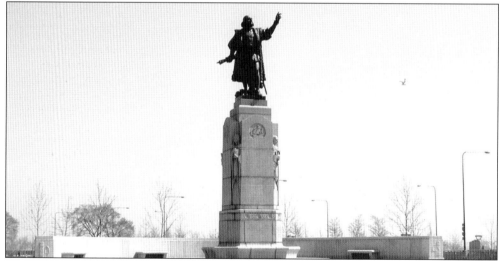

To celebrate the Century of Progress Exposition, members of Chicago's Italian community commissioned a giant 15-foot-tall bronze statue of Christopher Columbus on a large white marble pedestal to be placed in Grant Park. The statue, which features Columbus holding a scroll in his right hand and gesturing towards the heavens with his left, was unveiled at the exposition on August 3, 1933, (Italian Day) near Columbus Drive and Roosevelt Road. The statue is the work of Italian sculptor Carl Brioschi (1879–1941). It is one of several statues in Chicago of Christopher Columbus.

The Rosenberg Fountain stands in Grant Park near Michigan Avenue and 11th Street. It features an 11 foot bronze of Hebe, the Greek goddess of youth. She is perched upon a temple that once housed an exquisite and decorative water fountain. The work was made possible as a result of a gift of Joseph Rosenberg (1848–1891), who bequeathed $10,000 in his will for the creation of a fountain near his boyhood home at Michigan and 16th Street. The sculpture is the work of artist Franz Machtl and was unveiled in 1893.

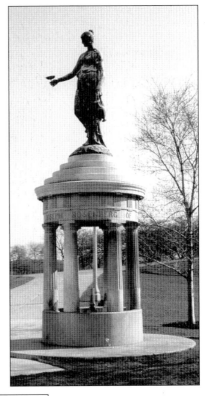

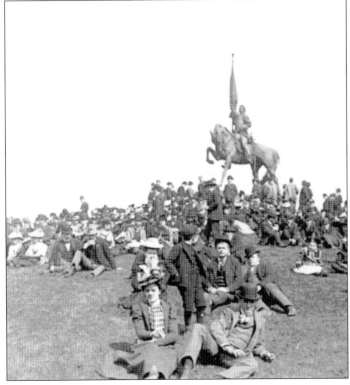

The General John A. Logan (1826–1886) Memorial is found in Grant Park near Michigan Avenue and 9th Street. Logan served in the Civil War and in the U.S. House of Representatives and Senate. He is depicted holding an upraised flag as a sign of inspiration to rally his troops. The statue was designed by Augustus Saint-Gaudens and Alexander Phimister and was unveiled on July 22, 1897. This photograph, taken in 1900, features a group of Chicagoans who are gathered at the memorial.

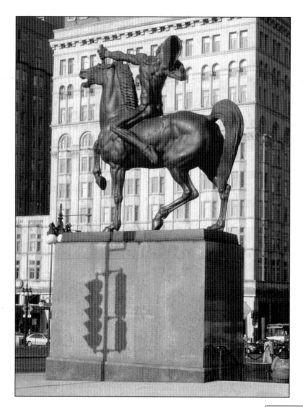

Entitled the *Bowman*, this is one of two nude Indian warrior sculptures that guard the entrance to Grant Park and are the work of sculptor Ivan Mestrovic (1883–1962). Set on massive granite pedestals, both warriors hold imaginary weapons although the Indian on the south pedestal is thought to be holding a bow. These works, which were cast in the artist's studio in Yugoslavia, are viewed by thousands of visitors everyday who pass through Grant Park or drive along Michigan Avenue.

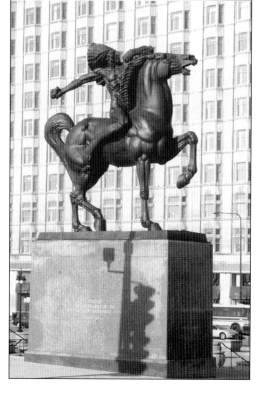

Considered the counterpart of the *Bowman*, this statue of the *Spearman* depicts a Native American warrior who appears to be throwing a spear. Like its match described above, it also stands approximately 17 feet high and weighs about 27,000 pounds. Both sculptures were commissioned by the B.F. Ferguson Monument Fund and unveiled in 1928. Although Mestrovic had wanted to place a cowboy and a Native American on the pedestals, it was believed that two Native Americans would be more appropriate representations.

In Grant Park, on either side of Congress Parkway just east of Michigan Avenue, there are two fountains. The centerpiece of each of these fountains is an eagle cast in bronze. The fountains and the eagles were commissioned by the South Park Board of Commissioners. They are the work of Chicago sculptor Frederick Cleveland Hibbard (1881–1955), and were unveiled in 1931. Several of Hibbard's other works are displayed throughout the city.

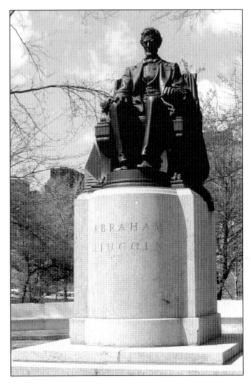

The Seated Lincoln is one of two statues of President Abraham Lincoln in Chicago by famed sculptor Augustus Saint-Gaudens (1848–1907). This one in Grant Park features a somber President Lincoln sitting in a chair atop a large granite pedestal. It took Saint-Gaudens 12 years to complete the work. The statue was commissioned by philanthropist John Crerar (1827–1889), who left a bequest of $100,000 in his will for the creation of a statue to honor President Lincoln.

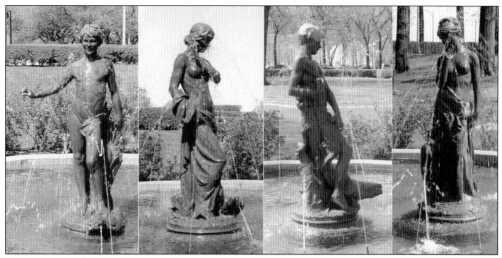

In Grant Park there are four rose gardens that flank each of the corners surrounding Buckingham Fountain. Each of the four gardens contain small fountains, which feature bronze figures by sculptor Leonard Crunelle (1872–1945). The fountains on the south feature *Dove Girl* and *Turtle Boy*, while the northern fountains feature *Crane Girl* and *Fisher Boy*. The figures were unveiled in Humboldt Park in 1905, but moved to their current location in 1964.

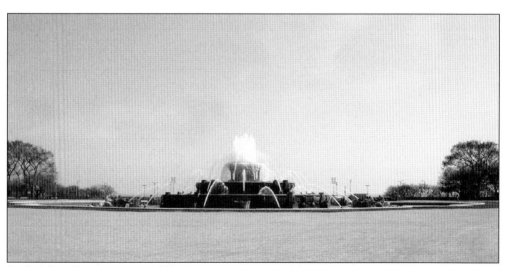

Buckingham Fountain, one of Chicago's most recognizable monuments, stands in Grant Park. It was the gift of Kate Sturges Buckingham (1858–1937) in honor of her brother Clarence (1854–1913). Unveiled on August 26, 1927, the fountain is modeled after the Latona Fountain in Versailles, France. The architects of the fountain were Bennett, Parsons, & Frost, of Chicago. The fountain is one of the most popular attractions in Chicago during the summer months.

This memorial to Theodore Thomas (1835–1905) entitled *The Spirit of Music* is located in Grant Park on Columbus Drive. Thomas founded the Chicago Symphony Orchestra and also served as its first conductor. The 15 foot bronze statue, which was designed by sculptor Albin Polasek (1879–1965), features the goddess of music holding a small harp. Unveiled in 1923, the statue originally stood across the street from Orchestra Hall on Michigan Avenue before it was moved to its present location in 1958.

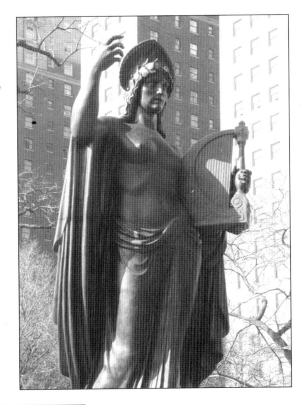

James Caesar Petrillo (1892–1984) was born and raised in Chicago. As a young man he learned to play the trumpet and became an organizer of the Chicago Federation of Musicians and president of the American Federation of Musicians. He soon became a powerful labor leader who vigorously championed for the rights of musicians. The labor czar even once appeared on the cover of Time Magazine. In 1976, the Grant Park Music Shell was named in his honor and this memorial to Petrillo can be found behind it.

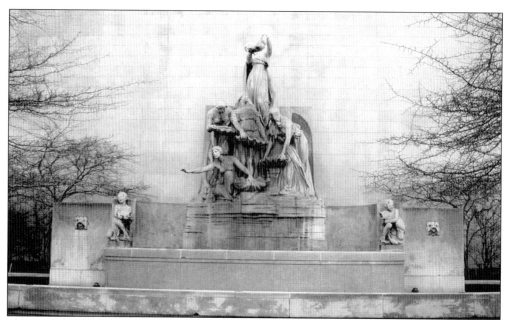

The Fountain of the Great Lakes, which was commissioned by the B.F. Ferguson Monument Fund, is found outside on the south wing of the Art Institute. The fountain features five female figures, each representing one of the five Great Lakes. The fountain is the work of sculptor Lorado Taft (1860–1936). The granite basin that holds Taft's creation was designed by the architectural firm of Shepley, Rutan and Coolidge. The fountain was unveiled in 1913 and moved a short distance to its present location in 1963.

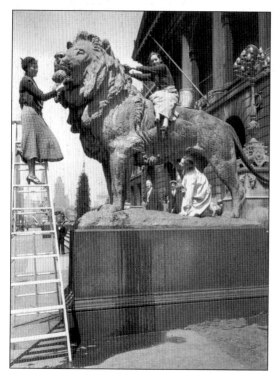

The two lions guarding the entrance to the Art Institute are among Chicago's most recognizable and beloved sculptures. The lions were cast for the World's Columbian Exposition in 1893. In 1894, they were donated to the Art Institute by Mrs. Henry Field who was the sister of Byran Lathrop, an Art Institute Trustee. The lion on the north end of the building is said to be *On the Prowl* and the south lion is known as *Attitude of Defiance*. They are the creation of the renown animal sculptor, Edward Kemeys (1843–1907). This photograph, which features three young ladies giving one of the lions a bath, was taken in the 1930s.

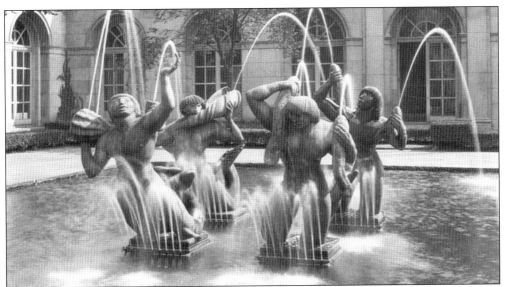

The Triton Fountain is the centerpiece of the Alexander McKinlock Memorial Court at the Art Institute. The fountain, completed in 1931, is the work of sculptor Carl Milles (1875–1955), who is considered by many to be one of the preeminent creators of fountains during the last century. This fountain features four tritons holding various shells and fish. It was modeled after another fountain that Milles created on the grounds of his home in Sweden. This photograph dates back to the early 1930s.

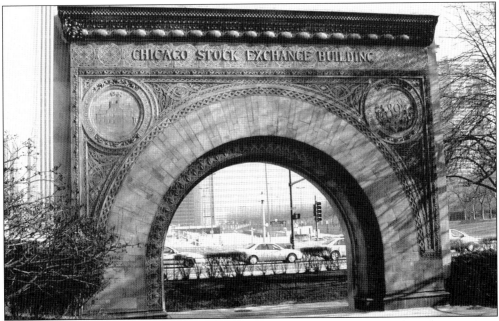

Built in 1893 by Adler & Sullivan, the Chicago Stock Exchange building stood on the southwest corner of LaSalle and Washington Streets. It was one of the finest examples of the Chicago school of architecture, but despite the best efforts of landmark preservationists to protect it, the building was demolished in 1972. The building's terracotta entrance arch was rescued and reassembled at Monroe Street and Columbus Drive behind the Art Institute of Chicago.

In 1999, *Cows on Parade* (an exhibit of over 300 fiberglass cows displayed throughout the city) became one of Chicago's most successful art exhibits. The two cows pictured here serve as memorials to this event. The cow on the left stands on the northwest corner of Washington and Michigan. The plaque below it reads: "In 1999, a herd of fiberglass cows united citizens, visitors, artists and businesses through a unique community-based public art event. This bronze cow is a gift to all Chicagoans in gratitude for their support of the cows and other art in public places." The cow on the right, entitled *Windy City Skyscrapers* can be found in the office of Mayor Richard M. Daley.

The Cancer Survivors Memorial features two 100-foot-tall Greek columns rescued from the old post office and Federal Courthouse downtown. The memorial was commissioned by Richard A. Bloch (b. 1926) and his wife Annette Bloch. (Mr. Bloch is the co-founder of the H & R Block tax preparation chain.) In 1978, Mr. Bloch was diagnosed with terminal cancer and given three months to live; but after aggressive therapy he was cured. As a result, he decided to resign from his company and dedicate his life to fighting cancer.

Four

THE NORTH SIDE

It is somewhat surprising that the largest concentration of monuments, markers, and memorials can be found on Chicago's North Side, because this area is not as old as other sections of the city. There are over 20 different works in Lincoln Park alone, including many by famous artists such as Saint-Gaudens, Hibbard, Rebisso, Crunelle, and Borglum. There is also an enormous statuary collection in both Graceland and Rosehill Cemeteries. Some of these works date back to the 1860s and the list of artists and architects who created them includes some of the world's most famous men.

The North Side is also home to a number of unusual monuments. Perhaps the most unusual is the Couch Tomb. Visitors often wonder why there is a burial mausoleum standing in the middle of Lincoln Park. This seemingly out-of-place monument is one of the few visual reminders that a portion of the park was once a cemetery. The memorials to the Tin Man and the Cowardly Lion that stand in Oz Park surely must make visitors scratch their heads in curious disbelief until they realize that Frank Baum, the author of *The Wizard of Oz*, wrote his famous work while living here in Chicago. Finally, Lorado Taft's monument to Dexter Graves (a hooded figure known as the *Eternal Silence*) is not only unusual but downright frightening.

Many figures forever linked with Chicago are memorialized with monuments on the North Side. Jane Addams, the founder of Hull House, is commemorated with a monument near Navy Pier, while Chicago writer and poet Eugene Field is honored with a memorial in the Lincoln Park Zoo. Director of the Chicago Symphony Orchestra Sir Georg Solti is remembered with a bust in front of the Lincoln Park Conservatory. For a tribute to early Chicago giants of industry such as Potter Palmer, George Pullman, Marshall Field, Daniel Burnham, and Louis Sullivan, all that is required is a stroll around Lake Willowmere in Graceland Cemetery.

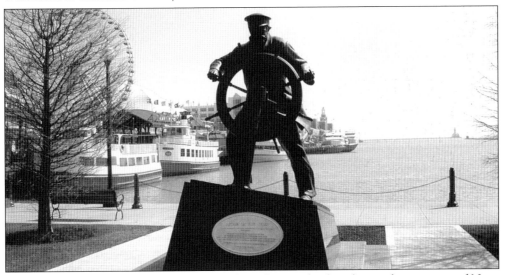

This bronze sculpture, entitled *Captain on the Helm*, can be found near the entrance of Navy Pier. The work features the captain of a sailing vessel standing at the wheel on a pitched deck. The work is a tribute to the courageous mariners who navigated their vessels through the perilous waters of the Great Lakes and made Chicago a major inland port. The statue, which was commissioned by the International Shipmasters Association and unveiled on May 19, 2000, is the work of sculptor Michael P. Martino (b. 1955).

Jane Addams Memorial Park, at 550 E. Grand Avenue, is named after the famous social reformer Jane Addams (1860–1935), who was also a settlement worker and author. The founder and director of Hull House, Chicago's first settlement house, she was awarded the Nobel Peace Prize in 1931. This monument to Addams, designed by Louise Bourgeois (b. 1911), was unveiled in the park on August 16, 1996. The monument consists of six granite blocks that display hands in different sizes and configurations. Addams once stated that she knew of nothing "so fraught with significance as the human hand," and the depiction of hands, rather than of her, illustrates this point.

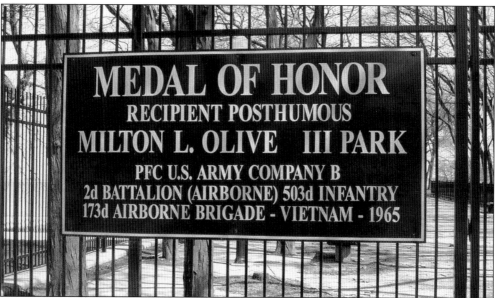

It would be nearly impossible to discuss Chicago's African-American heroes and not mention Milton Lee Olive III (1946–1965). Olive was born and raised in Chicago before joining the Army in 1965. While fighting in the jungles of Vietnam, an enemy grenade was thrown at his platoon. Olive pounced on the grenade absorbing the blast with his body, thereby saving the lives of the other members of his platoon. For his extraordinary heroism he was awarded the Congressional Medal of Honor, and on June 19, 1966, this park in front of the water filtration plant was named in his honor. There is also a bronze marker honoring Olive in the park.

William Dickson Boyce (1858–1929) founded the Boy Scouts of America on February 8, 1910. Since that time, it has been estimated that over 110 million young men have participated and benefited from Boy Scout activities. Boyce was also one of the most successful and wealthy publishers in Chicago during his day. These markers honoring him can be found on the exterior of the Boyce Building, which is located on the northwest corner of Illinois and Dearborn.

This bronze memorial to Eli Schulman (1910–1988) is located in Seneca Park at 228 E. Chicago Avenue. For nearly 50 years, Schulman was a Chicago restaurateur who owned and operated Eli's, which is located directly across the street from the park. His son Marc Schulman now operates the business, which still produces the world famous Eli's cheesecake that has become synonymous with Chicago. The memorial is the work of local sculptor and stone carver Walter S. Arnold, whose works can be found throughout the city.

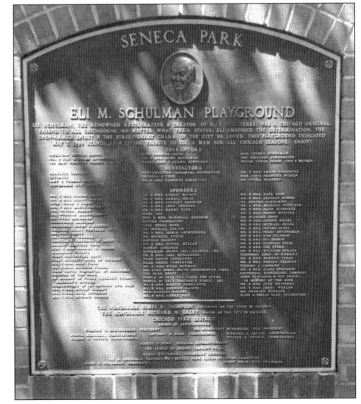

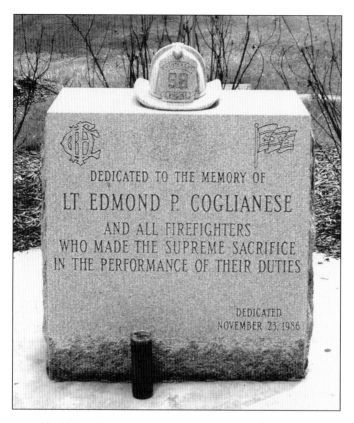

Pictured here is a memorial to Lieutenant Edmond P. Cogilanese (1943–1986). He was a Chicago fireman who was killed while fighting a blaze at the Mark Twain Hotel on the Near North Side on January 26, 1986. The memorial is located next to the 98th Engine Company Firehouse at 202 E. Chicago Avenue, where Cogilanese was stationed. His widow, Eileen Cogilanese, a member of the Gold Badge Society, has been instrumental in the creation of a new park which will honor Chicago firefighters killed in the line of duty.

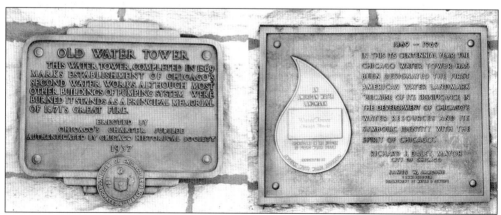

These two memorial plaques can be found on the exterior of Chicago's historic Water Tower at 806 N. Michigan Avenue. The marker on the left was erected in 1937 by Chicago's Charter Jubilee to honor the structure's historical significance. The marker on the right was placed here in 1969 to mark the 100th anniversary of the Water Tower. Designed by architect William Boyington, this 154 foot tower, which is made of Joliet limestone, was one of the few buildings to survive the Great Chicago Fire of 1871.

Pictured here is a bronze bust of Chicago merchant and banker Walter Loomis Newberry (1804–1868). His will provided for the founding of a library that would always be free and open to the public. In 1893, architect Henry Ives Cobbs completed construction of the Newberry Library at 60 W. Walton Street. Today it is one of the largest independent research libraries in the United States, housing an incredible collection of books, manuscripts, and historic maps. This bronze bust can be found in the lobby of the library, which is used by over 100,000 people annually.

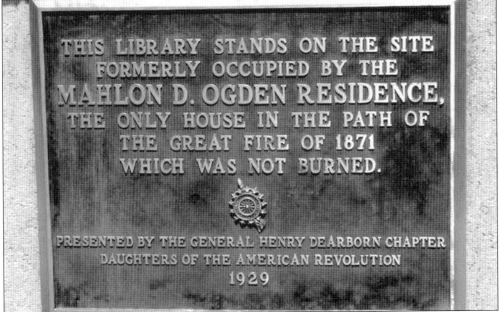

This memorial marker which is affixed on the exterior entrance wall of the Newberry Library honors the residence of Mahlon D. Ogden. Mr. Ogden was a prominent lawyer and the brother of William B. Ogden (1805–1877), Chicago's first Mayor. Built in 1856, his home was "the only house in the path of the Great Fire of 1871 which was not burned." The library now stands on the site. In 1929, the General Henry Dearborn Chapter of the Daughters of the American Revolution erected this marker.

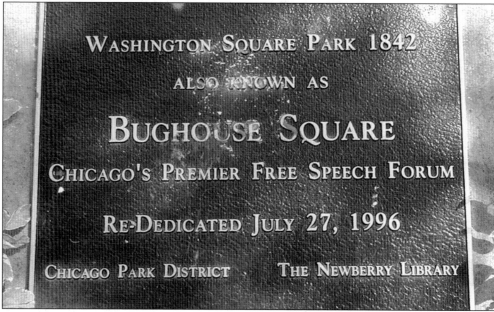

Washington Square Park (901 N. Clark Street) was established in 1842, and it is the oldest existing park in the city of Chicago. It is also known as "Bughouse Square" because it was the site of rambunctious lively debates and rousing nightly speeches. (Mental hospitals were also referred to as "bughouses.") Once a year, the Newberry Library, which is located directly across the street from the park, sponsors a festival that recreates the various debates and speeches by soap box orators that once took place in the park. This memorial tablet on the west side of the park designates the park as "Chicago's Premier Free Speech Forum."

Walter Payton (1954–1999) is considered by many to be one of the greatest athletes who ever played football. As a running back for the Chicago Bears he scored 125 touchdowns and became the NFL's all time leading rusher with 16,726 yards. He was an All-Pro seven times and led the Bears to a Super Bowl title in January of 1986. After his death from cancer in 1999, this school at 1034 N. Wells was named Walter Payton College Prep in his honor. In addition, a small street in front of Soldier Field was designated Honorary Walter Payton Place.

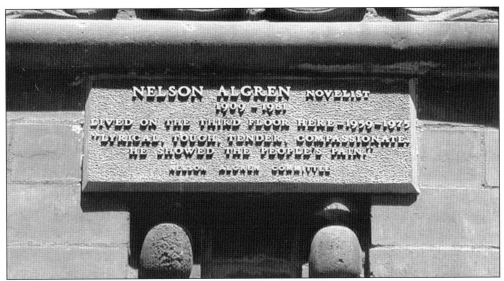

Nelson Algren (1909–1981) was a novelist and, without a doubt, one of Chicago's most famous literary figures. The setting of many of his books were the streets, alleys, and taverns of Chicago's tenement slums. His novels, which included *Never Come Morning* (1942), *The Man with the Golden Arm* (1949), *Chicago: City on the Make* (1951), and *A Walk on the Wild Side* (1956) are known for their brutal and realistic portrayal of life. Algren lived in Wicker Park on the third floor of a three flat at 1958 W. Evergreen from 1959 until 1975. This memorial marker has been placed on the exterior of the building in his honor.

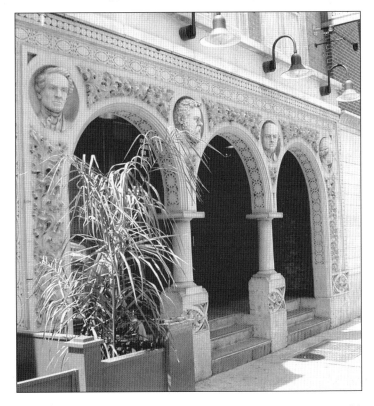

One of Chicago's most unique monuments is the facade of the legendary Old Town Second City Theater at 1616 N. Wells Street. The facade was salvaged from Adler & Sullivan's old Garrick Theater Building at 64 W. Randolph when it was being demolished in the 1960s. It features the busts of great German philosophers and writers that are believed to be the work of prominent sculptor Richard Walter Bock (1865–1949).

This sculpture of the Tin Man is a tribute to the mythical land of Oz. It is located in Oz Park at 2021 N. Burling Street. Author L. Frank Baum (1856–1919) wrote the *Wizard of Oz* in 1900 while living in Chicago. This 9 foot work weighs 900 pounds and is made of chrome automobile bumpers. It is the creation of renowned sculptor John Kearney (b. 1924) and was unveiled in October 1995. Many of Kearney's works are in museums and collections throughout Chicago and the United States.

Unveiled on June 1, 2001, the Cowardly Lion became the second *Wizard of Oz* character to be placed in Oz Park. Cast in bronze, and proudly wearing a badge of courage, the Cowardly Lion bears an uncanny resemblance to Burt Lahr, the actor who portrayed the lion in the motion picture version of the *Wizard of Oz*. Standing prominently in its place in the southeast corner of the park, the lion joins the Tin Man, which became the first sculptured citizen of Oz Park in 1995. Artist John Kearney created both sculptures. It is uncertain if there are plans to add the Scarecrow or other characters to the park's collection.

Opened on May 24, 1902, the Courtland Street Bridge is the world's first double-leaf trunnion bascule bridge. Known internationally as a "Chicago-style" bridge, it is basically a drawbridge whose two halves move up and down on a pair of horizontal shafts called trunnions. Bascule (a French word for "seesaw"), describes how the bridge operates. Designated an official city landmark, the bridge crosses the Chicago River and helps connect the Kennedy Expressway with Lincoln Park. A marker that is located east of the river honors the first "Chicago-style" bridge ever built.

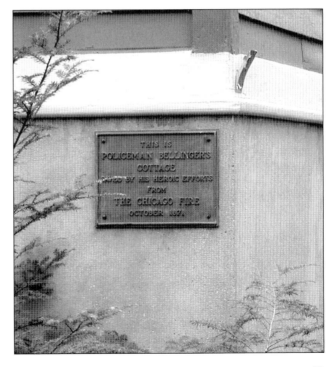

Policeman Richard Bellinger's cottage was one of the last homes to be saved as the Great Chicago Fire of 1871 swept through the city. By soaking the roof with water, Bellinger saved his Lincoln Park home, which was located on the northernmost edge of the fire. This plaque honoring his heroic efforts can be found on the front of the home at 2121 N. Hudson Avenue. The landmark home was built by architect William Boyington. Interestingly, the Chicago Water Tower on Michigan Avenue, which also survived the Chicago Fire, was built by Boyington.

During the summer months, North Avenue Beach becomes one of the most attractive and popular locations for chess enthusiasts. Here on the 37-foot-long limestone chess pavilion overlooking Lake Michigan, players compete from dawn till dusk in countless chess matches. Flanking both ends of the pavilion are 5 foot limestone sculptures by Evanston-born artist Boris Gilbertson (1907–1982). The sculptures represent the two most important pieces of any chess game, the King and the Queen. The works were unveiled in 1957.

Standing in front of the International College of Surgeons Museum at 1516 N. Lake Shore Drive is this statue entitled *Hope and Help*. This limestone work is the creation of sculptor Edouard Chassaing (1895–1974). It features a man in a surgical outfit holding another man who appears to have collapsed in his arms. The statue embodies the spirit of the medical profession, which is devoted to helping and healing its fellow man. The statue was unveiled on February 19, 1955.

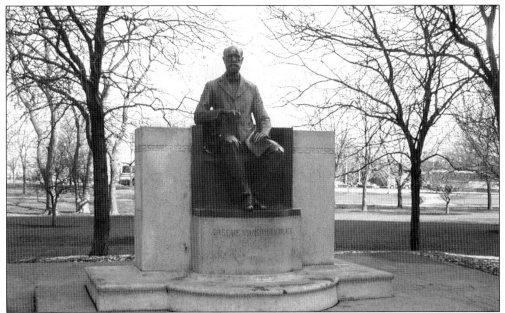

This statue of Greene Vardiman Black (1836–1915) sits in Lincoln Park near Astor Street and North Avenue. Black is considered to be one of the leading figures in modern dentistry. He helped organize the Northwestern School of Dentistry and was the author of several books on dentistry. The statue was commissioned by the National Dental Association, and it is the work of sculptor Frederick Cleveland Hibbard (1881–1955). It was unveiled on August 8, 1918.

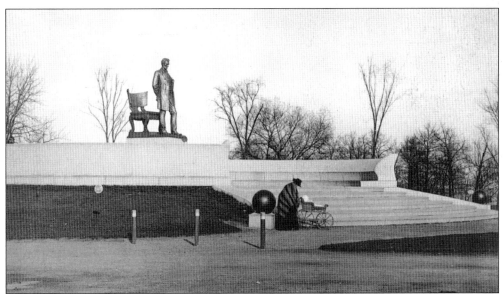

There are several statues of Abraham Lincoln in Chicago, but *The Standing Lincoln*, which is found behind the Chicago Historical Society at Clark Street and North Avenue, is considered to be one of the finest works of famous sculptor Augustus Saint-Gaudens (1848–1907). The statue of the great emancipator was commissioned by Chicago lumber merchant Eli Bates, who left a posthumous gift of $40,000 in his will for the creation of the work. The memorial was unveiled on October 23, 1887. This photograph was taken in the early 1890s.

An old relic from the Chicago Fire stands at Armitage and Clark Street near the entrance of the Chicago Academy of Science's Matthew Laflin Building. It is a piece of the old City Hall building that was destroyed in the Great Chicago Fire of 1871. The building stood on the same site as today's City Hall. Following the fire, this relic was placed on a small engraved pedestal near the entrance of Jackson Park. After being vandalized on several occasions it was moved north to Lincoln Park in a more visible location near Clark Street.

Standing in front of the Chicago Academy of Sciences Building at 2001 N. Clark Street, is this sculpture of two cougars. Entitled *Siblings*, the work was designed by sculptor Janet Rosetta Schockner. It was donated in 1997 to the Lincoln Park Zoo by philanthropist Charles C. Haffner III. (After nearly 40 years of service, Haffner retired from R.R. Donnelley & Sons as Vice Chairman in 1990.) He is currently a Trustee of the Newberry Library, the Art Institute of Chicago, the Morton Arboretum, and the Lincoln Park Zoo.

The southern portion of Lincoln Park was once an old cemetery. By 1866, however, the cemetery was closed, and shortly thereafter all the bodies and markers were officially removed except two: the Couch burial vault (which today still stands in the southeastern portion of the Park) and the Kennison Boulder, which lies a little further north. At the time, it was determined that the Couch vault, at 100 tons, was too heavy and too expensive to move and since the Lockport sandstone blocks that support the tomb had been cemented together with molten lead, its safe removal seemed virtually impossible. The exquisite wrought iron fence and most of the trees surrounding the vault have been taken away since the time when this photograph was taken in the early 1890s.

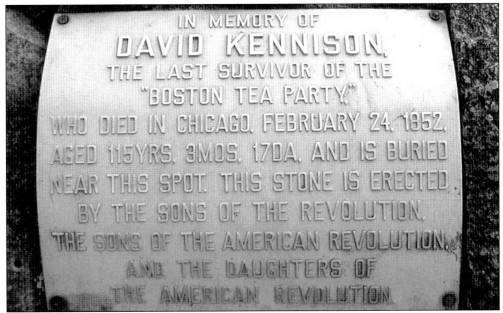

The Kennison boulder marks the general area where David Kennison (1736–1852) was buried. The last surviving member of the Boston Tea Party, he was 115 years old at the time of his death in Chicago on February 24, 1852. This marker was placed on his grave by the Sons and Daughters of the American Revolution. Throughout the years, various construction projects in the park have unearthed other remains that were unknowingly left behind. Some of the recently discovered bodies and bones of these unknown persons are now stored at the Chicago Academy of Sciences.

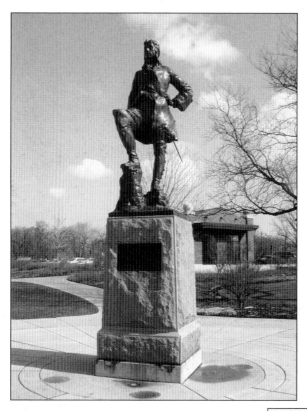

This monument to Robert Cavelier de LaSalle (1643–1687) was designed by Jacques de la Laing. LaSalle is depicted here armed with sword and pistol, long flowing hair, and legs encased in high leather leggings. The statue was cast in Belgium and shipped to Chicago, where it was unveiled on October 12, 1889. It is found in Lincoln Park, on the east side of Clark Street, north of the juncture with LaSalle Street. The monument was the gift of Lambert Tree (1832–1910).

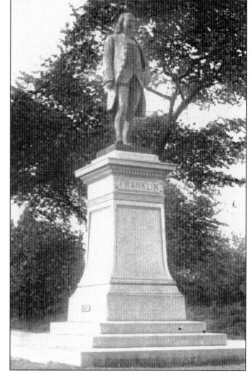

Pictured here is an early 1900s view of the Franklin Monument, which is located in the southern portion of Lincoln Park. This statue of Benjamin Franklin (1706–1790) was unveiled in the park on June 6, 1896, by one of his descendants. The monument, which was donated by Joseph Medill (1823–1899), is the work of sculptor Richard Henry Park (1832–1902). This is one of several statues by the artist that can be found in Chicago.

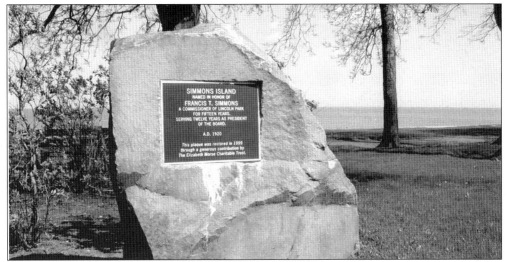

This memorial boulder, located in Lincoln Park east of Lake Shore Drive on Simmons Island honors Francis Tolles Simmons (1855–1920), an early Chicago park commissioner and reformer. The original marker was stolen a number of years ago. A new plaque honoring the accomplishments of Simmons has been placed on the boulder at a cost of $2,000, which was paid by the Elizabeth Morse Genius Charitable Trust.

Swedish Scientist, religious teacher, and mystic Emanuel Swedenborg (1688–1772) is honored with this memorial in Lincoln Park. At the unveiling in 1924, a crowd estimated at nearly 10,000 people gathered to hear a speech by the ambassador to Sweden, as well as enjoy music performed by a variety of Swedish musicians. A bronze bust of Swedenborg, by sculptor Adolph Jonsson, originally stood on this granite pedestal, but it was stolen in 1976. It has been replaced with the obelisk that is pictured here.

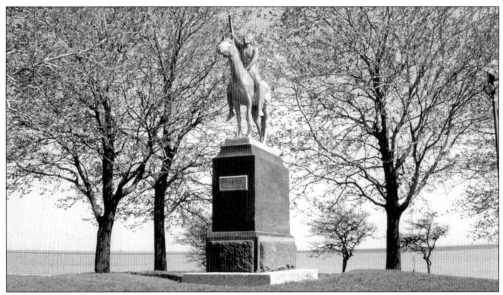

Entitled *Signal of Peace*, this monument represents a Sioux Chief on horseback. He is pictured holding a spear in his right hand, pointed upward in a gesture of peace. The work was designed by Cyrus E. Dallin (1861–1944) in 1890 and installed in 1894, north of the entrance to Diversey Harbor and east of Lake Shore Drive in Lincoln Park. It was donated by Lambert Tree (1832–1910), who had seen the work in 1893 at the World's Columbian Exposition.

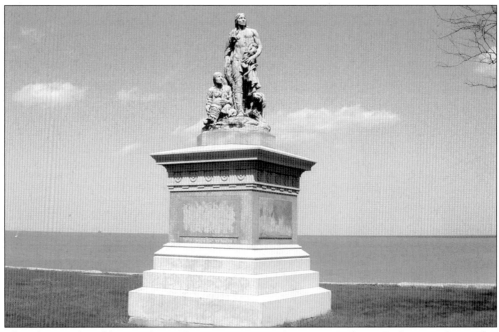

The Alarm is the oldest work in Chicago to portray American Indians. It depicts a brave, his seated squaw, their papoose, and a dog. All four figures seem to be alert to some pending danger. The statue was designed by John J. Boyle in 1884. The sculptor's donor was Martin Ryerson (1818–1887), who spent several years trading with the Indians. Located in Lincoln Park, east of Lake Shore Drive and overlooking Lake Michigan, it is the park's oldest monument.

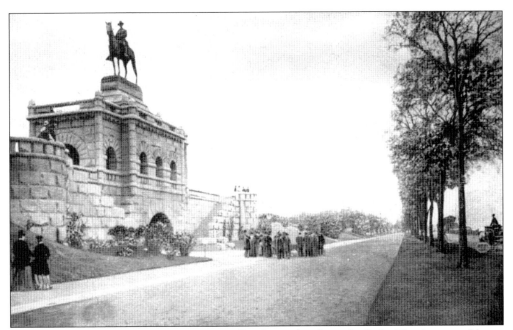

This statue of Ulysses S. Grant (1822–1885) is located in Lincoln Park. The figure and horse measure 18 feet, 3 inches from the bottom of the plinth to the top of the hat. The face of the figure shows a calm Grant in repose, atop a Kentucky thoroughbred that he rode during the Civil War. The statue was designed by Louis T. Rebisso and was dedicated in 1891. The cost of the monument was covered by voluntary contributions to a fund that was started shortly after Grant's death in 1885.

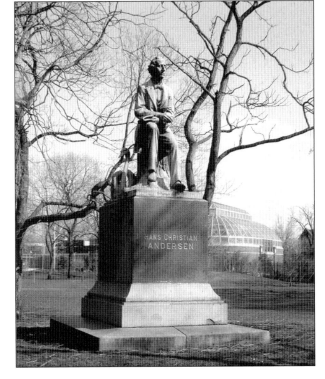

Sculptor John Gelert (1852–1923) designed this bronze memorial to author Hans Christian Anderson (1805–1875) that was unveiled in Lincoln Park on September 26, 1896. It features Anderson seated on a tree stump holding his place in a book that rests on his right knee. Behind Anderson is a swan, representing the "Ugly Duckling," one of his most popular stories. The monument was erected from funds raised by Danish citizens of Chicago and the United States.

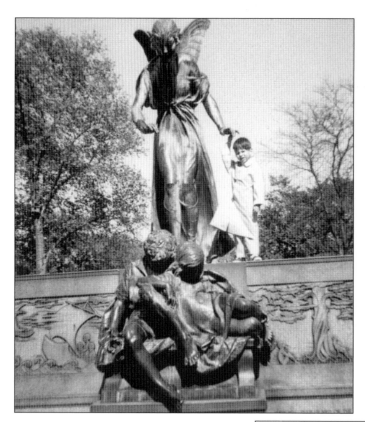

Eugene Field (1850–1895) was a journalist and a poet who wrote a very popular column called "Sharps and Flats" for the *Chicago Daily News*. In 1922, this sculpture dedicated to Field was unveiled near the Small Mammal House in Lincoln Park. This work by sculptor Edward McCartan (1879–1947) features an angel dropping flowers over two sleeping children. Verses from some of Field's most popular children's poems are engraved on the base of the statue. Pictured here is the author John Graf, at age five, standing on the statue's pedestal in May of 1968.

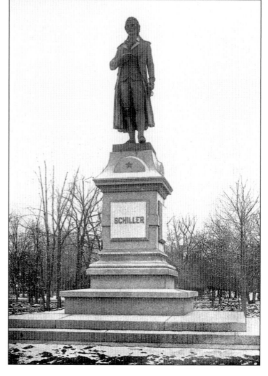

The bronze figure of the German playwright and poet Johann Christoph Friedrich von Schiller (1759–1805) is found in Lincoln Park at the southern end of the Conservatory Garden, east of Stockton Drive at Webster Avenue. It was designed by Ernst Bildhauer Rau (1839–1875) and was dedicated on May 8, 1886, before 8,000 people. The sculpture is a copy of the original that is located in a garden in Marbach, where Schiller was born.

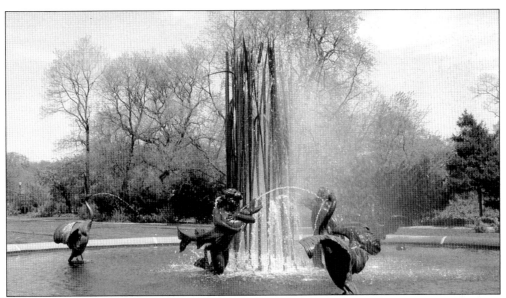

Pictured here is a fountain that stands in front of the Lincoln Park Conservatory, entitled *Storks at Play*. It is the work of sculptors Augustus Saint-Gaudens (1848–1907) and Frederick William MacMonnies (1863–1937). The fountain, which was unveiled in 1887, features a joyful group of bronze figures. There are boys playing with large fish, and storks spraying water from their beaks in a large circular pool. The fountain was the gift of Eli Bates, and, for this reason, this work is sometimes referred to as the Bates Memorial Fountain.

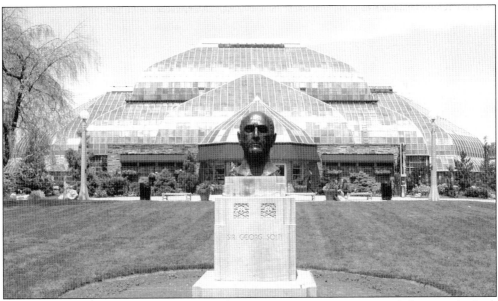

This large bust of Sir Georg Solti (1912–1997) can be found in front of the Lincoln Park Conservatory. Solti, a brilliant conductor and leading figure in musical culture in Europe and the United States, was the music director of the Chicago Symphony Orchestra from 1969 until 1991. He was knighted, awarded numerous honorary doctorate degrees, and won several Grammy Awards. On his 75th birthday, he received the Medal of Merit, Chicago's highest award, and was honored with the dedication of this bust of himself in Lincoln Park.

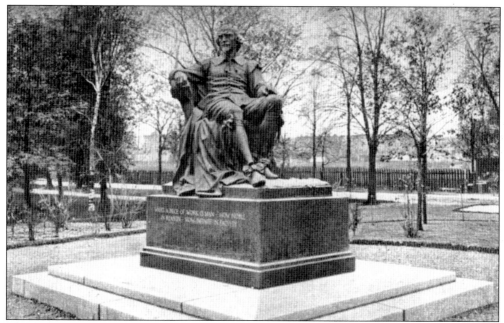

This statue of William Shakespeare (1564–1616) was designed by William Ordway Partridge, who studied 137 portraits of Shakespeare before he undertook the project. The statue was first seen at the Columbian Exposition, although it was always intended to be placed in Lincoln Park, where it finally rested in 1894. At the unveiling, there were lines of carriages along the roadways, and hundreds of people crowded around the pedestal. The work was cast in bronze in Paris and shipped to Chicago.

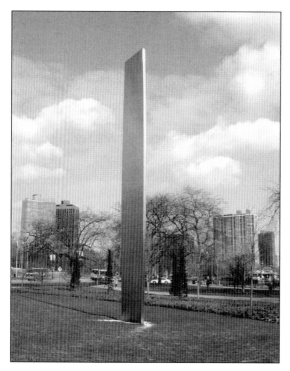

This 40-foot-tall rectangular steel monument in Lincoln Park near Cannon Drive and Fullerton Avenue was unveiled in 1981. It is the work of American abstract painter and sculptor Ellsworth Kelly (b. 1923). It was commissioned by Friends of the Parks, a non-profit organization dedicated to protecting and preserving Chicago's parks. The work, which is entitled I Will, represents the spirit of Chicago and its unofficial slogan.

Pictured here is a bronze sculpture of former Illinois Governor and United States Senator Richard James Ogelsby (1824–1899) that is located on a small hill in Lincoln Park a few blocks south of Diversey Parkway and just west of Cannon Drive. It features a standing Ogelsby with his hat in his right hand and his jacket folded over his left arm. This statue, which was unveiled on November 21, 1919, is the work of sculptor Leonard Crunelle (1872–1944).

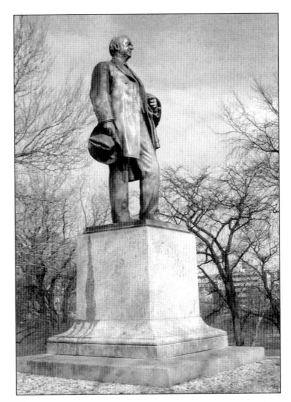

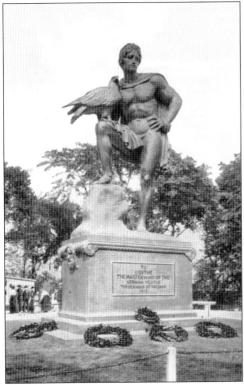

This is a 1915 photograph of the Goethe Monument in Lincoln Park. The statue is located near the southeast corner of Diversey Avenue and Sheridan Road across the street from the Elks Memorial. The work of sculptor Herman Hahn (1868–1944), the 25-foot-tall monument was unveiled in 1913 to honor the German poet, Johann Wolfgang von Goethe (1749–1832). There is also a street in Chicago that has been named after Goethe.

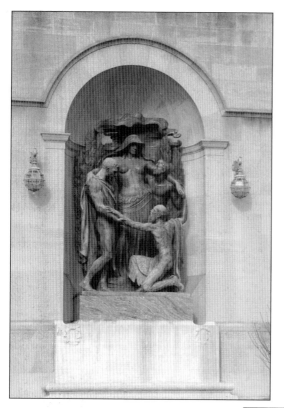

In the exterior facade of the Elks Memorial south wing is another sculpture by artist Adolph Alexander Weiman. This one, entitled *Fraternity*, also features four bronze figures. The central figure of this group is Mother Nature. Kneeling to her left is an old man and standing to her right is a young man who seems to be extending his arm in an effort to help the older man. Behind the kneeling figure is another young man who is looking up with admiration to Mother Nature. Drifting clouds and stars appear above the four figures.

A massive sculpture entitled *Patriotism* can be found in the exterior facade of the Elks National Memorial north wing, which faces Lincoln Park. Designed by sculptor Adolph Alexander Weiman (1870–1952), the work features a group of four bronze figures with an American Eagle hovering above them. Columbia, the central figure, is depicted holding a torch of liberty, while a mother and a boy are seen to her right. To her left is a man, partially obscured by a U.S. flag, who is offering his sword in defense of his country.

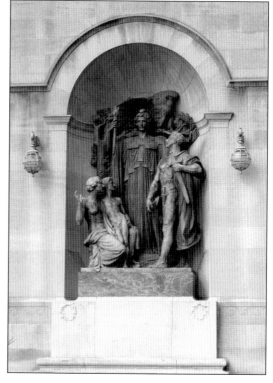

As most Chicagoans know, the entrance to the Art Institute is guarded by sculptor Edward Kemeys' Lions. Most people, however, are unaware that the entrance to the Elks National Memorial at 2750 N. Lakeview Avenue is guarded by sculptor Laura Gardin Fraser's (1889–1966) bronze elks. The Elks flank the grand staircase to the memorial, which was erected to honor the members of the Benevolent and Protective Order of Elks of the United States who gave their lives for their country in World War I and World War II.

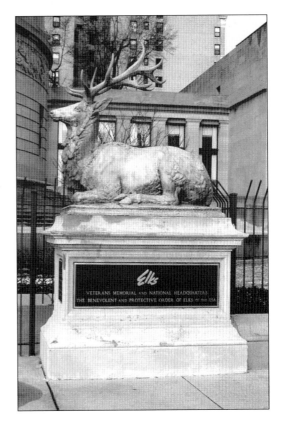

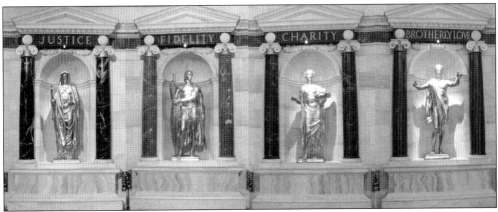

Once you open the giant bronze doors and pass through the arched doorway, you will enter the memorial rotunda of the Elks National Memorial. There you will be surrounded by an incredible interior that is almost entirely made of marble of every conceivable color. Two tiers of marble columns support the 100 foot dome, and works by sculptor James Earle Fraser (1876–1953) can be found in four separate niches. They are entitled *Charity*, *Justice*, *Brotherly Love*, and *Fidelity*, and represent the four virtues of the Order.

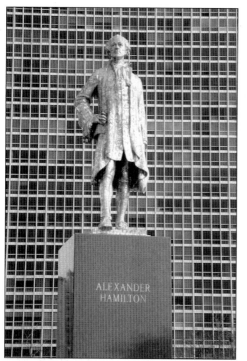

One of two monuments to Alexander Hamilton (1757–1804) found in Chicago's parks, this one in Lincoln Park near Diversey and Sheridan is the work of sculptor John Angel (1881–1960). The 13 foot gold leaf statue stands on a three-tiered pedestal. The work was completed in 1940 and installed in its present location in 1952. The statue is the gift of Kate Sturges Buckingham, who left a bequest of $1 million dollars in her will for the creation of this work.

John Peter Altgeld (1847–1902) is considered by many to be one of the most honest and courageous politicians who ever served the people of Illinois. While serving as Governor of Illinois, he pardoned three men wrongly convicted of murder in the Haymarket Riot. Today the pardoning is viewed as a noble act of courage, but at the time it was very controversial and cost Altgeld his political career. His statue, which can be seen in Lincoln Park near Cannon Drive and Diversey Parkway, is the work of sculptor Gutzon Borglum (1871–1941).

Jack P. Walsh Jr. (1923–1970) was a Chicago firefighter who was critically injured while fighting a blaze in July of 1970 at the Garcy Corporation at 1722 N. Ashland Avenue. Walsh remained in a coma for weeks and died on August 16, 1970. In a fitting tribute to him, a park was created on the site of the fire and named in his honor. In addition, this mosaic, which features a portrait of Walsh and a bronze plaque honoring the fallen firefighter, was erected on the firehouse wall at 2714 N. Halsted.

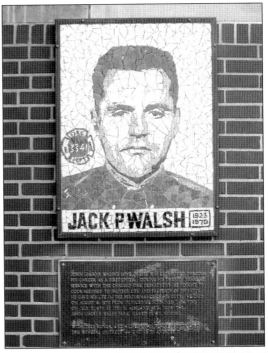

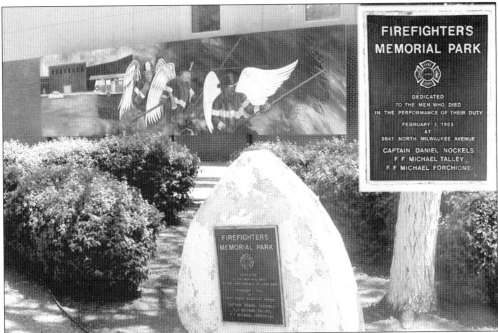

A plaque at Firefighters Memorial Park at Diversey and Kimball Avenues honors three Chicago firefighters who died in the line of duty February 1, 1985. The names of the three firemen are listed on the tablet: Capt. Daniel Nockels (1928–1985), Michael Forchione (1956–1985), and Michael Talley (1959–1985). They fell to their deaths when a roof collapsed during an arson fire in a two-story building at 2847 N. Milwaukee. A mural honoring the men can also be seen here in the background.

This memorial honors Sydney R. Marovitz (1910–1989), a former Chicago Park District Commissioner. It is located near the entrance of the old Waveland Golf Course, which is now known as the Sydney R. Marovitz Golf Course. An avid golfer, Marovitz often played this course. The memorial placed there is the work of local sculptor Walter S. Arnold and reads: "Sydney R. Marovitz, one of Chicago's most popular and beloved citizens, spent his life trying to help others." The nine-hole public course is one of the city's most popular courses.

This replica of the famous Kwa-Ma-Rolas totem pole was donated to the park district in 1929 by James Lewis Kraft (1874–1953). Standing approximately 40 feet high, it can be found just east of Lake Shore Drive at Addison Avenue. In 1985 the original totem pole was returned to the Canadian tribe that manufactured it. Some people have tried to blame the Chicago Cubs' misfortune on the totem pole. Legend has it that totem poles are supposed to face east to bring good luck to the area where they are erected, but this one faces west and brings bad luck to the Cubs, who play a short distance away.

In front of the offices of the St. Joseph's Hospital at Sheridan Road and Diversey Parkway are two sets of identical bronze sculptures. Entitled *Brotherhood.* the sculptures are the work of artist Egon Weiner (1906–1987). The sculptures feature a circle of four figures in a kneeling position—two men and two women with their arms linked together. Each sculpture is engraved with a different set of inscriptions. One reads "Friendship," "Justice," "Knowledge," and "Peace," and the other reads "Brotherhood," "Equality," "Liberty," and "Tolerance."

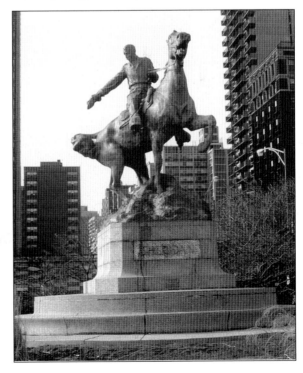

The monument of Civil War hero General Philip Henry Sheridan astride his beloved horse Winchester is located on the corner of Belmont Avenue and Sheridan Road. It depicts Sheridan leading his men into battle against Confederate troops. The memorial is the work of sculptor Gutzon Borglum (1871–1941), who is better known for his design of Mount Rushmore. One hundred thousand people including General Sheridan's daughter, Mary Sheridan, attended the unveiling on July 16, 1924. A curious side note is the fact that baseball players from visiting teams at nearby Wrigley Field have been known to paint portions of General Sheridan's horse in their teams' colors. In recent years, Chicago police have begun cracking down on this practice.

One of the city's more intriguing markers can be found across the street from Wrigley Field at 3633 N. Sheffield Avenue. The marker reads "Eamus Catuli!" and "AC135794". The marker was put up in April, 1996, as a trivia challenge for Cubs fans. It turns out that "Eamus Catuli" in Latin means "Let's go Cubs," although the more precise translation is "Let's go whelps." The meaning of "AC135794" is a little more complex. AC represents the Year of the Cubs, 13 is the number of years since the Cubs clinched their division, 57 is the number of years since the Cubs won the pennant, and 94 is the number of years since the Cubs have won a World Series. The numbers are changed accordingly at the start of each new baseball season.

Carmella Hartigan (b. 1902) is a living memorial. At age 100, she is one of the oldest Chicago Cub fans around and one of the few who was alive when the Cubs last won the World Series in 1908. She still sits in the bleachers and attends games on a regular basis. Hartigan has lived on the North Side since coming over from Italy in 1910 and often rides the bus from her home to the game. This is a photograph of her at Wrigley Field.

One of the most recent additions to Chicago's rich sculpture collection is that of legendary broadcaster Harry Caray (1914–1998), who was an announcer with the Chicago White Sox for 11 years before moving to the North Side in 1982 to broadcast Cubs games. Caray was well-known for his colorful analysis of games and his rousing rendition of "Take me Out to the Ballgame," which he sang during the seventh inning stretch of every Cubs' home game. The 7-foot, white-bronze statue that stands in front of Wrigley Field at 1060 W. Addison was unveiled on April 12, 1999. It is the work of sculptor Omri Amrany.

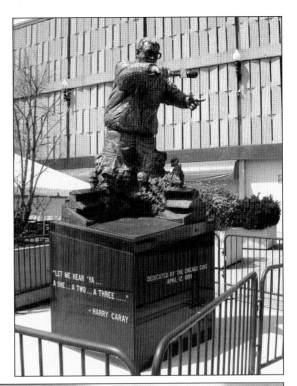

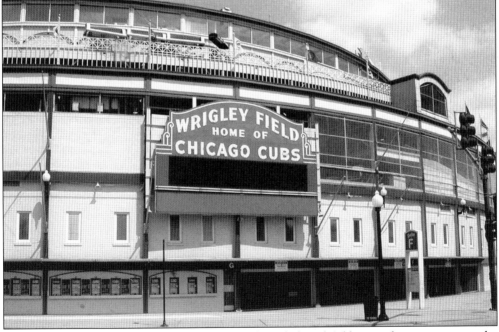

Located above the main entrance of Wrigley Field at Clark and Addison is this monument to the Chicago Cubs. Although the ballpark was built in 1914, it was not named Wrigley Field until 1926, and this sign was not installed until the 1930s. In the 1980s an electronic message board was installed on the lower portion of the historic sign. This large red neon sign, which reads "Wrigley Field Home of Chicago Cubs," has become one of Chicago's most recognizable landmarks.

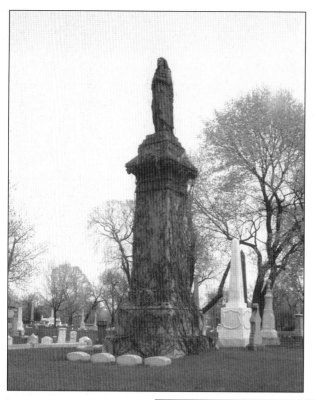

As you enter historic Graceland Cemetery, this towering monument to Eli B. Williams (1799–1881) is one of the first memorials you see. Williams was a very early settler who came to Chicago from Connecticut in 1833. He made a fortune in real estate and public utilities and ran for Mayor in 1851 but was defeated. The monument features a woman holding a cross. During the summer months, the memorial is almost completely covered with ivy. Other members of the Williams family are also buried on the same plot.

This is a memorial to Frederick Wacker (1830–1884). Mr. Wacker was a German immigrant who came to Chicago in 1854. One of the early members of the Chicago Board of Trade, he was also one of the best known beer barons in the city. His wife Catherine, who also died in 1884, is buried alongside him. Wacker Drive is named after their son Charles H. Wacker (1856–1929), another prominent Chicagoan. This unique monument is located in Graceland Cemetery. The photograph was taken in the early 1890s.

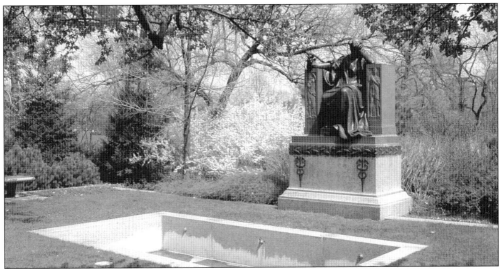

Marshall Field (1834–1906) was one of the most successful men in the history of Chicago. Even today it is possible to shop at one of the many Marshall Field's stores in Chicago and throughout the country. This elegant monument, entitled *Memory*, was erected in Graceland Cemetery during the early 1900s in honor of Field. The statue is the work of sculptors Daniel Chester French (1850–1931) and Henry Bacon (1866–1924). In 1922, these two sculptors again collaborated to create the Lincoln Memorial in Washington D.C. There is, in fact, a striking similarity between the Field Monument and the Lincoln Memorial.

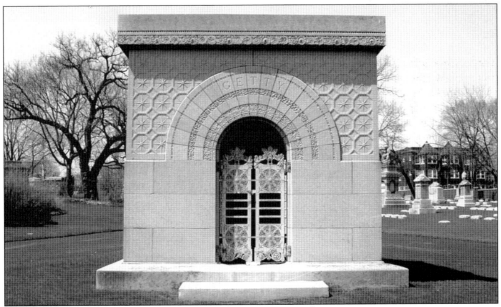

Considerd by many to be an architectural masterpiece, the Getty Tomb was designated as a Chicago landmark in 1971. Designed in 1890 by architect Louis Sullivan (1856–1924), this exquisite structure is made of Bedford limestone and bronze. The tomb contains the bodies of Chicago lumber merchant Henry Harrison Getty (who commissioned Sullivan to build the memorial), his wife Carrie Eliza, and their daughter Alice. The Getty Tomb is located in Graceland Cemetery.

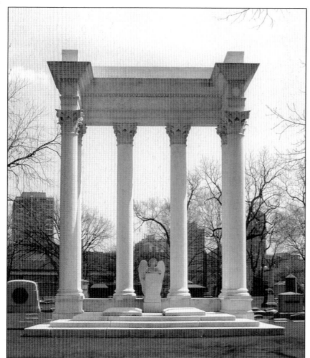

William Kimball (1828–1904) came to Chicago in 1857 and became the largest manufacturer of pianos and organs in the world. One of the wealthiest men in Chicago, his mansion at 1801 S. Prairie still stands. After his death, a classically-inspired limestone memorial with six colossal columns was erected at Graceland Cemetery to honor his memory. The monument was designed by the prestigious architectural firm of McKim, Mead & White.

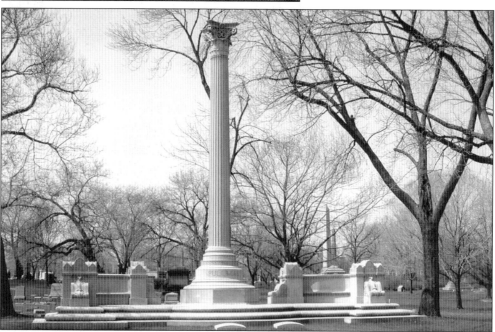

George Mortimer Pullman (1831–1897) was a Chicago industrialist who made his fortune as the inventor of the railroad sleeping car. His simple but elegantly designed memorial features a tall Corinthian column surrounded by stone benches. What lies beneath his memorial is a little more complex. Fearing retaliation by discontent workers, his family had his coffin covered with tar and asphalt and sunk in a block of concrete. The block was then covered with railroad ties and more concrete. Today, it is still considered one of the most elegant memorials in Graceland.

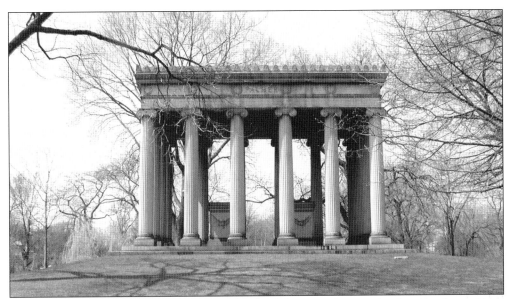

One of the most grandiose memorials in Graceland Cemetery honors the first merchant prince of Chicago, Potter Palmer (1826–1902) and his wife Bertha Palmer (1849–1918). This lavish tomb reflects the lifestyle the Palmers enjoyed as one of Chicago's wealthiest families. Designed by McKim, Mead & White, this classically-inspired temple consists of 16 Ionic columns that surround the granite sarcophagi of the Palmers. The memorial sits high on a hill overlooking Lake Willowmere.

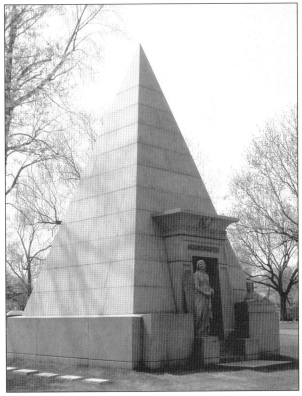

One of the most intriguing memorials in Chicago is that of beer baron Peter Schoenhofen (1827–1893), who is entombed in a large pyramid at Graceland Cemetery. The entrance to the pyramid is guarded by a sphinx and an angel who is holding a key and looking upward toward the sky. The sphinx and the angel make for a rather unusual combination as angels are typically found on Victorian monuments. Nonetheless, this remains one of the most popular monuments at the cemetery.

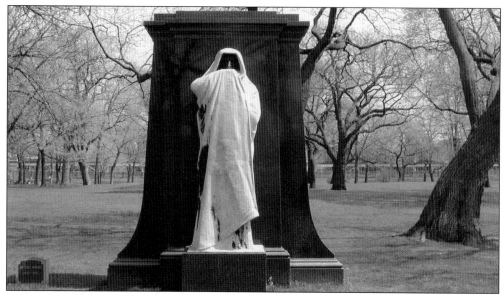

The *Eternal Silence*, by sculptor Lorado Taft (1860–1936), was designed to honor the memory of pioneer Chicagoan Dexter Graves (1789–1844). The sculpture, which has been nicknamed "The Statue of Death," features an eight-foot cloaked and hooded figure against a polished black granite background. The mysterious figure has one arm partially covering his deeply recessed face. One might easily surmise that the figure depicted is the Grim Reaper. In any event, it is certainly one of the most eerie and haunting memorials ever created. Commissioned by Henry Graves (son of Dexter Graves), the memorial was unveiled in 1909.

Located on a wooded isle in Lake Willowmere is the memorial dedicated to Daniel Hudson Burnham (1846–1912). The monument, which consists of a large granite boulder accompanied by a bronze tablet, is accessible by a small concrete bridge, and it sits in one of the most peaceful and serene locations in all of Graceland. Burnham was an architect and city planner as well as the head of construction for the Columbian Exposition and author of the 1909 *Plan of Chicago*.

LOUIS HENRI SULLIVAN

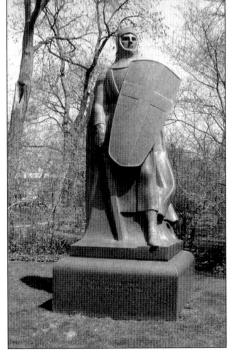

One of the most famous architects in Chicago and the world was Louis H. Sullivan (1856–1924). He is considered by many to be the father of modern architecture as well as the chief theorist of the Chicago School. Incredibly, Sullivan's work was not fully appreciated during his lifetime. As a result he died a pauper and it was not until five years after his death that a monument was placed on his lot at Graceland. The monument is the design of architect Thomas Tallmadge. It features a bust of Sullivan in the center of a geometric bronze design.

Victor Fremont Lawson (1850–1925) was a philanthropist and also the publisher of the *Chicago Daily News* from its inception in 1875 until his death in 1925. In 1931, this black granite monument of a medieval Crusader by sculptor Lorado Taft (1860–1936) was erected upon his final resting place. The only words found on this memorial are "Above All Things Truth Beareth Away the Victory."

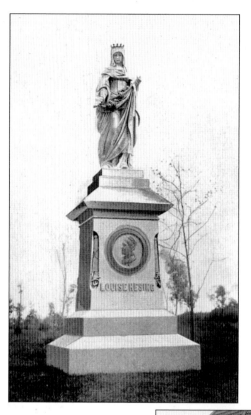

One of the most beautiful yet little-known monuments in the city is dedicated to the memory of Louise Hesing. This statue depicts St. Elizabeth in a beautiful dress, holding roses as she distributes bread to the poor with her outstretched hand. The statue is seven-and-a-half-feet-tall and stands on a nine-foot-high pedestal made of light gray Westerly granite. This monument is the work of sculptor Franz Engelsman and is located in St. Boniface Cemetery at 4901 N. Clark. This photograph was taken in the early 1890s.

This statue, entitled *Mother*, is the work of sculptor Albin Polasek (1879–1965). The statue features a woman lovingly tending her children. It was unveiled before a crowd of 25,000 in 1927. Polasek's other works in Chicago include the Theodore Thomas Memorial and the Gotthold Ephraim Lessing Monument. At one time, the Czech-born Polasek was the head of the Chicago Art Institute's sculpture department. The statue can be found in front of the chapel at Bohemian National Cemetery at 5255 N. Pulaski.

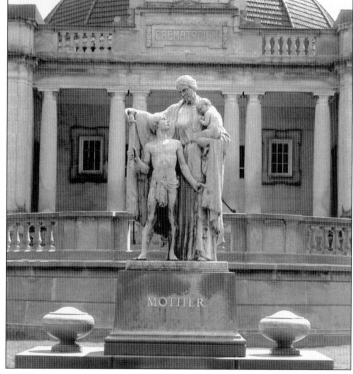

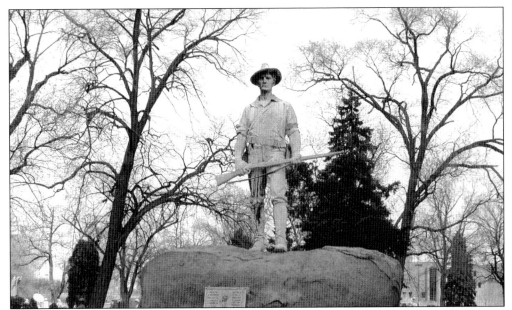

The Spanish American War Memorial, commonly known as the "Hiker Monument," was erected on September 24, 1926. The bronze memorial features a lone soldier perched upon a large granite boulder. He is depicted holding a rifle while dressed in his battle gear. The statue was commissioned by a group of Bohemian veterans who served in the Spanish American War. The statue is located at Bohemian National Cemetery, 5255 N. Pulaski.

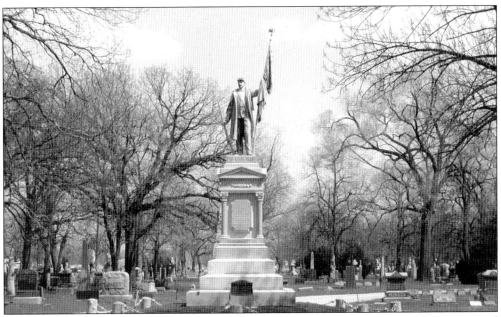

The Civil War Veterans Monument was dedicated in 1889. This bronze statue features a Civil War soldier holding his rifle in his right hand and a flag in his left hand. It was commissioned by the Grand Army of the Republic. The GAR was a veterans group formed after the Civil War. It was responsible for a large number of monuments in Chicago. The statue is located at Bohemian National Cemetery at 5225 N. Pulaski.

As you enter Rosehill Cemetery at 5800 N. Ravenswood on Chicago's North Side, this work will be one of the first monuments you see. It is a bronze statue of Charles J. Hull (1820–1889) seated upon a large pedestal. Hull was a wealthy real estate developer in early Chicago history. This statue is the work of sculptor Richard Henry Park (1832–1902). Several other works by Park, including the Drake Fountain and statues of Michael Reese and Benjamin Franklin, can be found throughout the city.

Rosehill Cemetery is the final resting place for over 350 Civil War soldiers, so it is appropriate that this 30-foot-tall monument, named *Our Heroes*, be placed in the cemetery. A Union soldier stands atop the limestone shaft holding his bugle in one hand and a flag in the other. At the base of the column there are four bronze markers that honor the four branches of service: artillery, cavalry, infantry, and navy. This memorial is typical of Leonard Wells Volk's (1828–1895) work, which features extremely tall monuments.

The Volunteer Fire Fighters' Monument, 1864, commemorates the 15 members of Chicago's volunteer fire brigade who are buried on the plot. Designed by Leonard Wells Volk (1828–1895), the monument was erected by the Firemen's Benevolent Association six years after the city disbanded the volunteer companies, replacing them with a paid fire department in 1858. The monument was refurbished and rededicated in 1979, and a granite marker with the names of the 15 fire fighters listed on it was placed at the base. The monument can be found just inside the main gate at Rosehill Cemetery at 5800 N. Ravenswood Avenue.

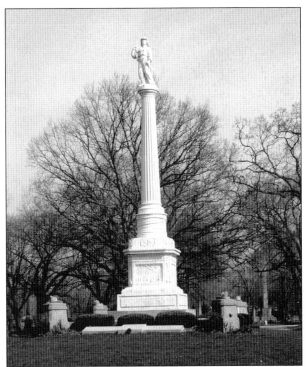

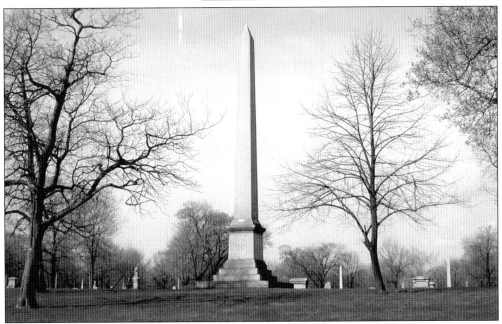

"Long John" Wentworth (1815–1888) served as Mayor of Chicago from 1857 until 1858 and again from 1860 until 1861. He was also a journalist, real estate developer, and close friend of Abraham Lincoln. Wentworth, (who weighed 300 pounds and stood at 6-feet, 6-inches tall) is one of twelve Chicago mayors buried at Rosehill Cemetery. His 72-foot-tall obelisk, which was erected in 1880, was carved from a single piece of granite. Standing on nearly two-thirds of an acre, it is the cemetery's tallest monument.

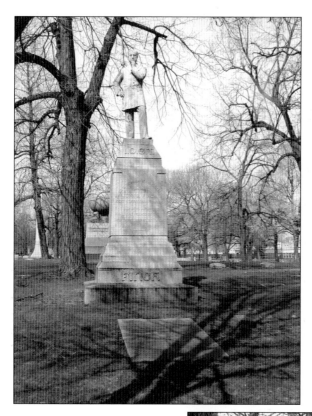

This bronze monument to John B. Finch (1852–1887) can be found in the far northeast section of Rosehill Cemetery. Finch was a very intelligent young man who began teaching school in 1870 (at age 18) and lecturing on temperance. He joined the International Organization of Good Templars and became Chief Templar and Chairman of the Prohibition National Committee in 1884. Finch was a very popular leader, but before he could reach his full potential, he died of a heart attack in 1887 at the age of 35.

On December 30, 1903, 602 people were killed in a fire at the Iroquois Theater on Randolph Street where the Oriental Theater now stands. The building, which was billed as "absolutely fireproof," was anything but that. After a curtain caught fire, the audience of nearly 1,900 people panicked. As patrons tried to flee the rapidly-spreading fire, they became trapped either by locked exit doors or doors that only opened inward. Unable to escape, many people were crushed and trampled to death. This four-foot square granite monument at Montrose Cemetery, 5400 N. Pulaski, was erected to honor the victims.

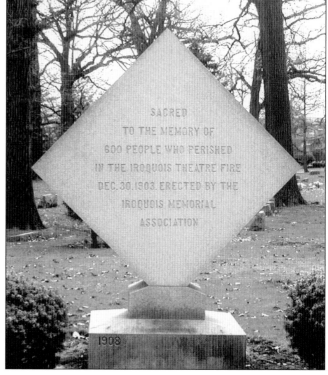

Pictured here is the 13-foot-tall bronze monument, entitled *Young Lincoln*, created by sculptor Charles Keck (1875–1951). It is located in Senn Park at 5887 N. Ridge Avenue. A hotel and tavern known as the Seven Mile Inn, which was built in 1848, once stood on this site. Abraham Lincoln attended a political caucus and stayed overnight at the inn during his 1860 campaign for president. This statue of him has been placed in the park to commemorate the occasion.

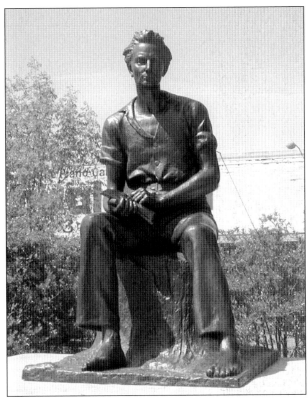

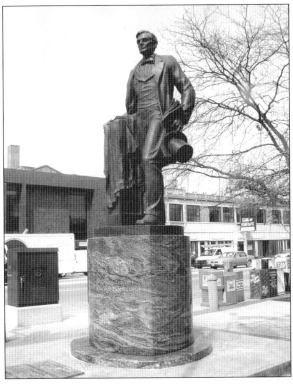

This statue, located on the northeast corner of Lawrence and Western Avenues, is one of several of Abraham Lincoln that can be found here in Chicago. This sculpture features a young Lincoln without his beard. In his left hand he is clutching his hat and some books. His right hand rests upon a podium, and the inscription on the base of the statue reads: "Free society is not, and shall not be, a failure." This statue was unveiled in 1956 and is the work of sculptor Avard Tennyson Fairbanks (1897–1987).

Pictured here is a monument to Rev. Jerzy Popieluszko (1947–1984) that stands in the courtyard of the predominately Polish St. Hyacinth parish at 3636 W. Wolfram. Father Popieluszko was a popular Roman Catholic priest in Warsaw, Poland, who supported the outlawed Solidarity labor union and spoke out against communism. On October 19, 1984, he was kidnapped and killed by the Polish secret police. It is believed that his death greatly contributed to the collapse of communist rule in Poland. He is now a candidate for sainthood in the Catholic Church.

This large red granite monument by sculptor John David Brcin (1899–1983) honors Henry Horner (1878–1940). Horner was born and educated in Chicago. He became a lawyer, judge, and Governor of Illinois from 1933 until 1940. This monument stands at the entrance of Horner Park at 2741 W. Montrose. It originally stood in Grant Park, but was moved to its present location in November of 1956, and was dedicated on December 5, 1956. The work was commissioned by the State of Illinois.

Edward Fox Photography is located at 4900 N. Milwaukee Avenue. It is the second oldest family photographic studio in the United States. Edward Fox was born in 1880 and opened the studio in 1902. This statue depicts Edward Fox at work. The sculpture was commissioned by Dick Nopar, Mr. Fox's grandson.

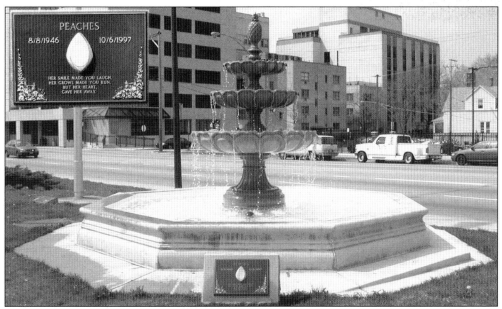

This fountain at 5850 N. Ashland Avenue honors Rosalie Peachy Siegel (1946–1997). Affectionately known as "Peaches," she loved gardening and worked across the street at the Gethsemane Garden Center at 5739 N. Clark Street for 20 years. She is buried at Rosehill Cemetery where flowers are almost always found on her grave. The drive to create this memorial fountain was led by Alderman Mary Ann Smith, who heads the City Council Committee on Parks and Recreation.

This monument in Indian Boundary Park at 2500 W. Lunt Avenue on Chicago's North Side honors our country's founding father, George Washington (1732–1799). This monument was originally a keystone taken from the arch of the Washington Street entrance to the old City Hall, which stood from 1877 until it was razed between 1906 and 1908. The Washington monument, which is one of several located in the park, was unveiled on July 4, 1927.

This is a photograph of prominent sculptor Erik Blome. He is pictured here in his studio next to an unfinished 7-foot-tall bronze of Dr. Martin Luther King Jr. Blome grew up in the Chicago area and many of his works are displayed throughout the city. Some of these works include a monument to the Chicago Blackhawks in front of the United Center, a bust of Thurgood Marshall in a branch of the Chicago Public Library, a bronze bust of James Jordan located in a West Side office of the Boys and Girls Club of Chicago, and a bust of Reverend Johnson, the founder of the Inner Voice on the city's West Side.